IMAGES
of America

MOAB AND GRAND COUNTY

ON THE COVER: Fisher Towers rise above the Richardson Amphitheatre as LaDue Williams snaps a photograph in 1931. The Williams family enjoyed exploring the wild lands of Grand County at first by horseback and later in their motorcar.

IMAGES
of America

MOAB AND
GRAND COUNTY

Travis Schenck and the Museum of Moab

ARCADIA
PUBLISHING

Published by Arcadia Publishing
Charleston, South Carolina

Printed in the United States of America

Library of Congress Control Number: 2013937627

For all general information, please contact Arcadia Publishing:
Telephone 843-853-2070
Fax 843-853-0044
E-mail sales@arcadiapublishing.com
For customer service and orders:
Toll-Free 1-888-313-2665

Visit us on the Internet at www.arcadiapublishing.com

To the people of Moab, who make history every day.

CONTENTS

Acknowledgments 6

Introduction 7

1. The Land 9

2. Surrounding Communities 33

3. Moab Streets and Buildings 53

4. People of Moab 83

ACKNOWLEDGMENTS

It is a difficult thing putting a book together and more difficult in turn to record the history of a community. I am grateful for the work that was done before me by the curators and volunteers of the Museum of Moab. Their tireless efforts to preserve and research the photographic history of the Moab area provided the seed to get this book going. I would further like to thank the Museum of Moab Board of Trustees who approved the creation of this book and the staff of the Museum of Moab—Andrea Stoughton, Billie Provonsha, Lindsey Bartosh, Larry Velasquez, and Sara Galabraith—for their support in making this work possible. Additionally I would like to honor Virginia Fossey and Verlyn Westwood who shared many of the stories I have used in this work with me long before I had even conceived of putting the book together. Finally I would like to thank my wife, Heather Schenck, for her never-ending patience as we put many things on hold to get this together. All photographs used in this work are courtesy of the Museum of Moab.

INTRODUCTION

The end of the Mexican-American War in 1848 brought the land that would someday be known as Grand County into the Union. Army surveyor Capt. John Macomb was not impressed with America's new acquisition and described the area as being a waste and wilderness. One hundred years later, thousands would flock to that wasteland looking for Uranium. Some would find riches but others would find a singular community set among the spectacular natural beauty of the Colorado Plateau. Between the Macomb expedition and the uranium boom of the 1950s, the settlement, founding, and growth of Moab and Grand County paint a colorful story of one of the last frontiers of America.

Grand County's story begins long before the first white settlers or Spanish explorers entered the valley. The land holds ruins, artifacts, and remnants of many ancient peoples. Ute, Navajo, Ancestral Puebloan (sometimes called Anazasi), Fremont People, and many earlier tribes—who are only remembered through paintings, petroglyphs, and the few items that have survived the ravages of time—all made Moab and Grand County their home. Small, fertile valleys protected by massive sandstone walls provided shelter and food to growing populations of Native Americans. At one time, it is estimated that nearly 10,000 Native Americans inhabited Grand County. War, disease, and drought led many to abandon the high deserts of the Colorado Plateau, and by the 1700s, as Spanish missionaries began to explore the area, they found scattered nomadic bands of Native Americans.

The Spanish sought gold and souls and found little of either in Grand County, leaving behind only a trade route from New Mexico to California. The first European inhabitants of Grand County would not be the Spanish, but instead the French. In the 1830s, demand for beaver fur among the world's wealthy led to an explosion of the fur trade industry. This inspired French Canadian trappers to begin to explore the riverways of the West. Traveling down the Green and Colorado Rivers, these mountain men established forts and left behind inscriptions telling of their passage through Grand County. Names like D. Julien and Antonie Robiduex dot the canyon walls of Grand County, telling of the visitation of these adventurous entrepreneurs.

With the annexation of the western United States, the Colorado Plateau became part of the great western expanse. New settlers sought new beginnings in the wilderness. Among them were members of the Church of Jesus Christ of Latter-day Saints, known as Mormons, who would found what would become Utah. The Mormons were founded in America, but their unusual professions of prophets and additional books of scripture led members to be driven out of the Midwest. Following their leader, Brigham Young, successor to their founder Joseph Smith Jr., the Mormons settled in the vast open spaces of the Great Basin. Young would organize the colonization of an area that reached from the Canadian border to Mexico and from California to the Continental Divide. A canny leader, Brigham Young recognized the importance of controlling trade routes through his territory, and with that in mind began to send missionary expeditions to build forts throughout the territory, which Latter-day Saints named Deseret. It was one of these missionary expeditions

that would build the first modern building in Grand County, a small stone fort that would house 41 men who sought to irrigate and settle the Moab Valley. Their efforts were in vain, and by the 1860s, only a few native tribes made the area home.

In the late 1870s, these last tribes would be rounded up by the US Army and re-settled on reservations in northern Utah and Colorado. Only a few "renegade" bands survived in hiding, and they soon found their former territories inundated by settlers.

Rays, Maxells, Olsens, Slades, Wheelers, Taylors, and Wilsons would all arrive and begin building homes, drilling wells, and laying out a community. Some settlers arrived from northern Utah looking for space to get away from the increasingly urban Salt Lake City, while others arrived from Texas and New Mexico looking for new ranges to graze their cattle. Soon the valley was teeming, and there was such sufficient demand that a post office was requested. In 1880, the name Moab appeared in the US Postal Register. The name had been chosen by William Peirce, a businessman who became Moab's first postmaster. His choice of name was a reference to the biblical desert of Moab located beyond the Jordan River. In 1902, Moab would officially be incorporated, and despite some protest that the name was unacceptable, it remained.

In the north part of Grand County, the completion of a railroad brought towns like Thompson, Cisco, and Stateline to life. Smaller towns like Sego and Westwater sprang up to provide services to the railroad. The rails brought new settlers from across the world. Basque sheepherders, Chinese laborers, and African American cowboys all became residents of the growing county. Industry sprang up as well, with prospectors combing the county looking for gold, oil, and uranium. Ranchers raised cattle and competed with vast herds of grazing sheep for territory. In the Moab Valley, orchards sprang up providing peaches, apples, pecans, and other crops. The *Grand Valley Times*, later the *Moab Times-Independent*, declared that peaches from Moab were served at restaurants in Paris.

With the railroad came America's first tourists, who were looking to explore what was still the Wild West. Rail companies were quick to promote the beauty of the West to sell tickets. In Moab, local doctor John J. Williams and Hungarian prospector Alexander Ringhoffer wrote letter after letter to railroads and politicians seeking to create a national monument. Their work would pay off with the designation of Arches as a monument in the 1930s. The town continued to grow, building new schools, a hospital, and courthouse, and all the amenities of modern life.

War drew young men away from Moab as they served in the First and Second World Wars. Between the wars, young men from the Civilian Conservation Corps arrived and worked to improve roads and irrigation and prevent erosion. In the 1940s, the CCC closed camps in Grand County as the young men went to war. The vacant buildings would find use as an internment camp for Japanese Americans accused of being un-American.

World War II's end brought new prosperity to Moab as the search for uranium increased. High-grade uranium ore was believed only to be found in Canada and parts of Africa, but in 1951, Charlie Steen, an impoverished geologist from Texas, discovered high-grade uranium ore south of Moab in Lisbon Valley. Overnight, the town was transformed. Orchards gave way to housing developments, schools were filled to the brim, sometimes running late into the night, and men dreamed of becoming millionaires like Charlie had. By the end of the 1950s, the small agricultural community on the Colorado River had grown to a city in the desert with 10,000 to 12,000 residents. Once again the city was reborn, as new schools were built along with a new hospital, new bridges, and roads to meet the needs of new settlers.

Moab and Grand County's story is like the sandstone cliffs of the surrounding landscape, each part layered a bit at a time, growing together one on top of another. A prosperous native village vanished, to be replaced hundreds of years later by a growing town. Orchards replaced stands of willows, only to be replaced by homes for a growing population. The Old Spanish Trail became Highway 191 and Interstate 70. Cattle trails transformed to roads bringing miners to work and then changed again to biking trails bringing tourists to see the natural beauty of Grand County. Each of these layers, building upon another, colors blending together, create a history of survival and prosperity—the story of Moab and Grand County.

One

THE LAND

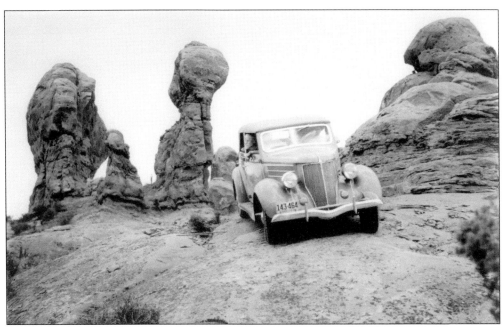

Dr. John J. Williams looks out of the first automobile to drive through Arches National Monument in 1936. When the monument opened in 1929, visitors took wagons, rode horses, or hiked to see the arches and sandstone formations. Harry Goulding, a trading post owner from Monument Valley, took advantage of his new balloon tires to explore the monument. In the background, Balanced Rock, the largest sandstone formation, looms over the smaller Chip Off the Old Block, which has since collapsed.

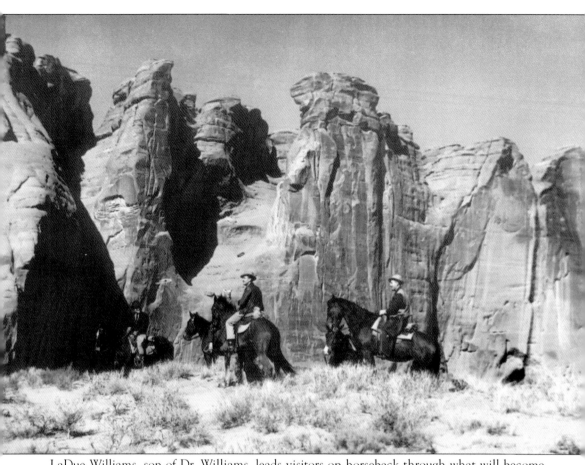

LaDue Williams, son of Dr. Williams, leads visitors on horseback through what will become Arches National Park. In 1920, when this photograph was taken, visitors to Arches came by horse. LaDue's father worked tirelessly to convince senators, railroad owners, and visitors to Grand County that the Arches area should become a national monument.

LaDue Williams, on horseback, poses beneath Double Arch in the windows section of Arches. The Williams family ran cattle through what would become Arches. Long days of watching herds and moving them from waterhole to waterhole made the Williamses familiar with the beauty of the Arches and inspired them to work toward preserving the sandstone wonders.

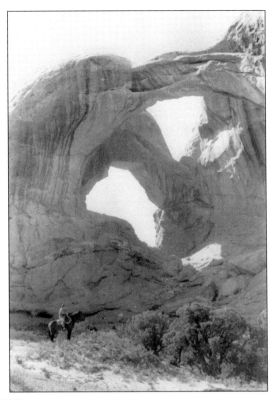

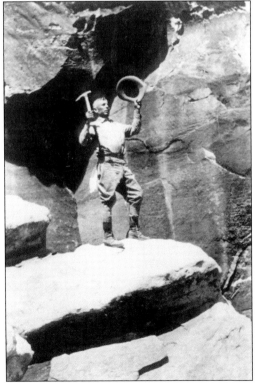

Alexander Ringhoffer, an immigrant from Hungary, stands in the Devils Garden in 1922. Ringhoffer prospected the area that he called the Klondike Bluffs at the turn of the 20th century. Though he never became rich, he fell in love with the beautiful sandstone canyons and arches. Joining forces with Dr. Williams, Ringhoffer wrote to numerous politicians and business owners to include the Klondike Bluffs in a national monument.

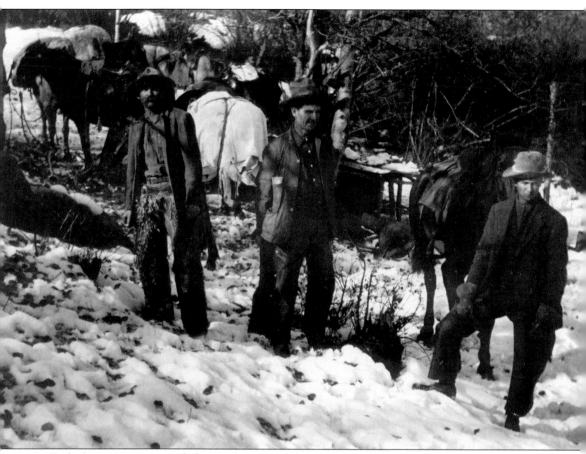

Early forest rangers patrol the southern La Sal Mountains. This photograph, taken in 1912, shows rangers Jack Palmer, Roy Colton, and Howard Balsley traveling on horseback through the mountains. Early rangers in the La Sals worked tirelessly to manage logging and ranching operations that used the mountains as a base. Most often, they found themselves enforcing grazing rights and chasing off cattle rustlers.

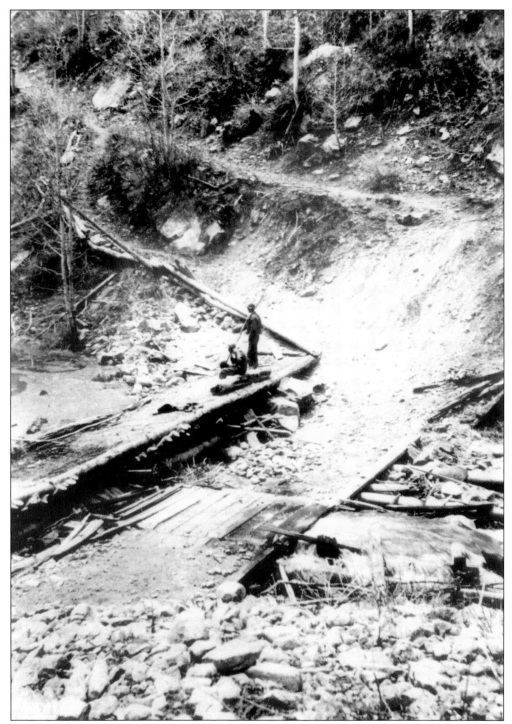

A bridge spans the outlet of Lake Oowah in the La Sal Mountains. Most of the lakes in the La Sals are man-made. Lake Oowah was developed by the forest service as both a recreation area and a water hole for cattle. Beginning in the 1920s, the Manti–La Sal Forest began to make improvements to trails, campgrounds, and lakes to provide recreation opportunities.

Numerous sawmills like this one in Bulldog Canyon operated on the La Sal Mountains during the early 1900s. The growing towns of Grand County required huge amounts of lumber, stone, and bricks to build new buildings. One of the first sawmills built in 1881 on the La Sals was near Mont Hill overlooking the Paradox Valley on the eastern slopes of the mountains. Despite the large numbers of sawmills in operation on the La Sal and Blue Mountains, the forest did not suffer the degree of deforestation that plagued many other western forests.

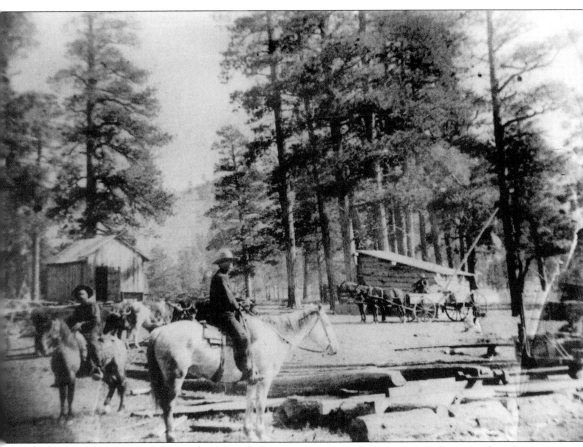

The La Sal Pass Sawmill was photographed in operation in 1894. Dan McCollum, on the white horse, is reported to have had the first sawmill on the La Sal Mountains, located near La Sal Pass. Later, new owner Tom Branson transported it to several different locations. Branson was an early lumberman in the area. His nickname was "Hell Roarin' Tom."

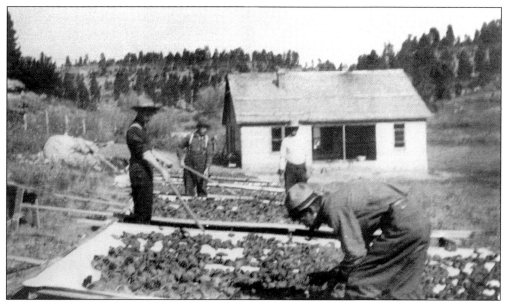

Pictured in the La Sal National Forest around 1910 are pinecones being dried in order to retrieve their seeds. Early forest rangers picked the pinecones and dried them on sheets, then tried to extract the edible pine nuts. Native Americans have long collected the seeds for their nutritious value; however, the popular method was to beat the tree with a long stick and gather the seeds from a blanket spread below. Some of the seeds pictured here may have been used for reforestation, but the majority were consumed by the rangers. From left to right are Roy Colton, forest supervisor Albert Bergh, forest supervisor Rudolf Mellenthin, and Jack Palmer.

Ever the entrepreneur, Dr. Williams worked a number of different enterprises in Moab including a ranch down the river from Moab. The Williams family spent summers at their ranch, where the canyon winds kept them cool in the hot months. The fertile banks of land along the Colorado River provided ready farmland for settlers around the 1880s. Though many families came to the area to farm along the river corridor, most of the farms did not survive. Like the other river farmers, the Williams family eventually gave up their ranch, leaving behind the name Williams Bottom.

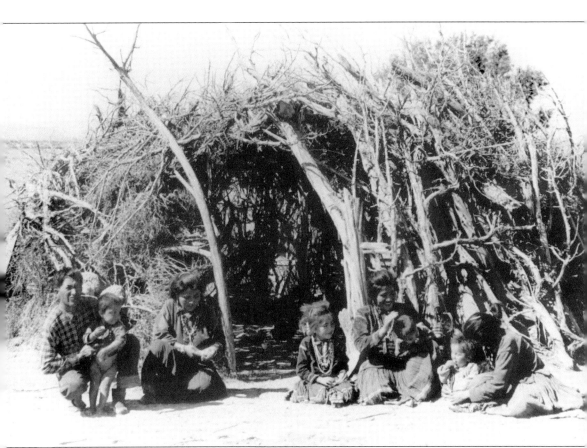

A Native American family spends a summer afternoon in front of their wickiup. These brush structures provided shade and shelter for many of the tribes throughout the Four Corners region. Until the 1700s brought horses to the Colorado Plateau, most tribes used wikiups for shelter. Horses traded from Plains tribes brought a transformation to tribes, who began to adapt to use tepees instead of wickiups. Eventually, as families switched to automobiles, the wickiup returned to provide easy shelter from the surrounding environment.

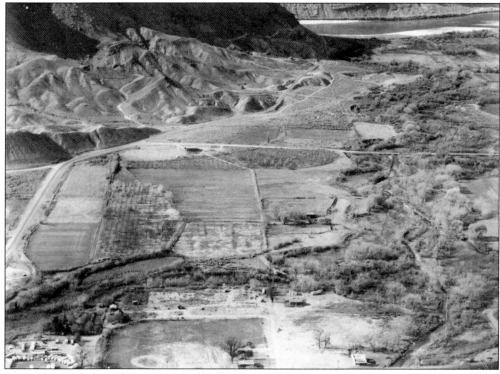

An early aerial shot of the Moab Valley in the 1930s shows the confluence of Mill and Pack Creeks near fields and orchards, with the Colorado River in the background. The majority of Moab settlements took place north of the two creeks, which had a tendency to flood with spring snowmelt or flash thunderstorms. By the 1930s, several families had begun to build homes south of the creeks, but growth was slow until the Main Street Bridge was constructed in the 1960s.

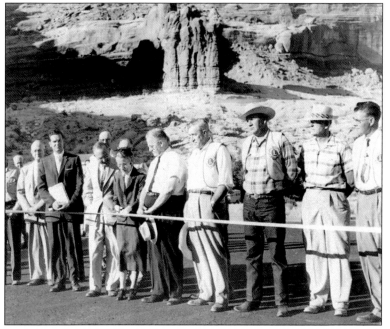

Lavina Williams cuts the ribbon opening the southern entrance to Arches National Monument in 1958. Lavina's husband, Dr. Williams, died two years earlier at the age of 103, before the new entrance to the park was completed. Until 1958, visitors to the park entered through Willow Springs Road on the west side of the park.

Two Bureau of Land Management (BLM) workers cross the Courthouse Wash on a hand-pulled cable car. During the 1930s, the BLM carefully monitored a number of washes throughout Grand County, checking for the flow of water and erosion. As the Dust Bowl raged in the Midwest, government agencies began to look toward fragile soil resources throughout lands under their management. The cable car allowed the workers to measure the flow of the wash without putting themselves at risk from floodwaters. The cable car stood until the 1980s when it was removed because of troublemakers "historically reenacting" the workers' trip.

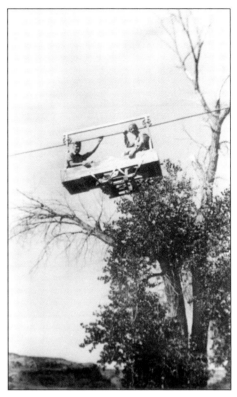

The Turnbow family members are pictured in 1918 at their cabin on the Wolfe Ranch in what would become Arches National Park. The Wolfe Ranch consisted of 150 acres in the heart of Arches. They ran cattle throughout the Arches. The Turnbows lived on the Wolfe Ranch until 1947, then sold it to Emit Elizondo, a sheep rancher who later sold it to the park service.

19

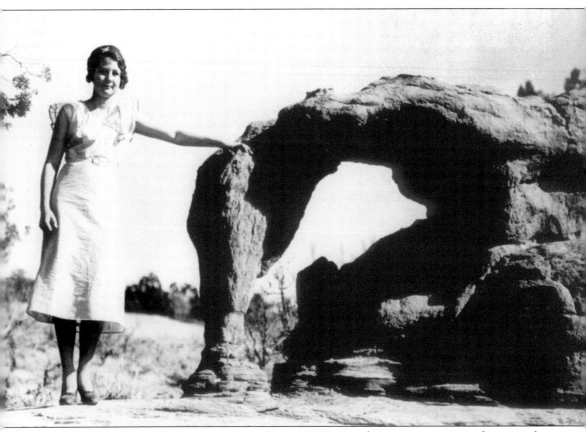

Marge Turnbow stands near Anteater Arch in 1934. Time and erosion are constant factors in the creation and destruction of the sandstone monuments found in Arches. Like many larger arches, Anteater Arch eventually succumbed to the wear of time and collapsed. New arches have since been named Anteater, and the cycle continues.

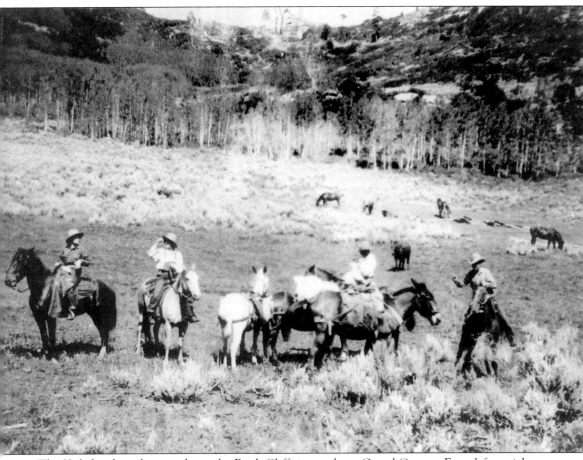

The Kirk family gathers cattle on the Book Cliffs in northern Grand County. From left to right are Neva Clark Kirk, Bess Davis, Charlie Glass, Dorothy Kirk, and R.L. "Buck" Kirk. The Kirks ran sheep and cattle on the book cliffs, which provided ample grazing, but their distance from towns made the livestock easy prey for poachers. In the 1920s, Thompson Springs provided an easy way for families running sheep and cattle on the Book Cliffs to take their herds to eastern markets to sell.

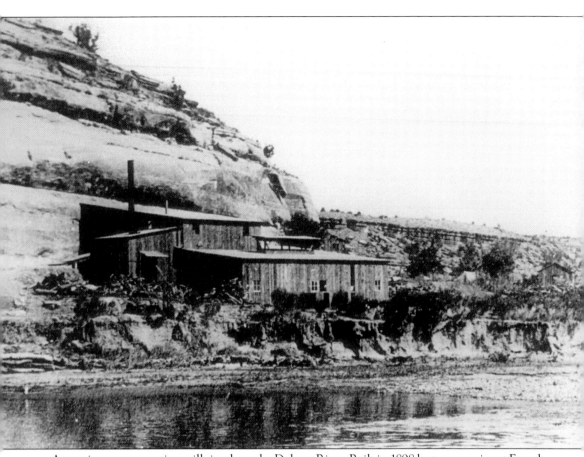

A uranium concentration mill sits along the Dolores River. Built in 1898 by two prominent French chemical scientists, Pouilot and Volique, this uranium concentration plant is thought to be the first in the world, capitalizing on the large concentrations of the newly discovered radium and uranium ore located in the area surrounding the La Sal Mountains. It is said that Marie Curie obtained her radium for her experiments with x-rays from this mill.

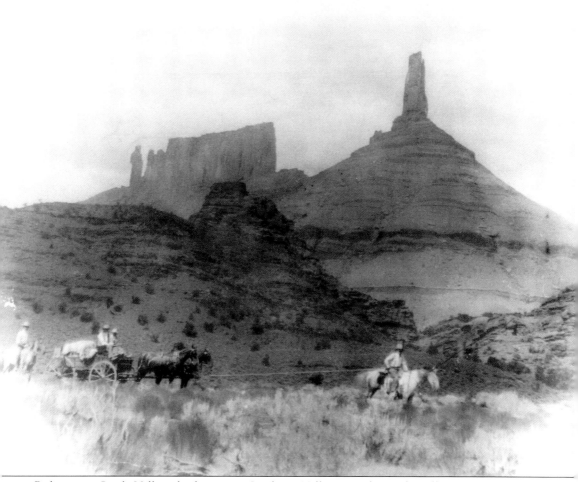

Riders cross Castle Valley, also known as Castleton Valley or Little Castle Valley, in 1898. This long, narrow valley was created when a dome of salt deposits collapsed. Until 1901, travelers to Castle Valley took a narrow, winding descent called the Heavenly Staircase, which descended from the southwest Porcupine Rim to the valley floor. Early settlers founded ranches and the towns of Castleton and Miner's Basin. In the background, Castleton Tower, sometimes called Castle Rock, stands near the Priest and Nuns Rock formations. In 1901, a toll road opened following the path of the Colorado River.

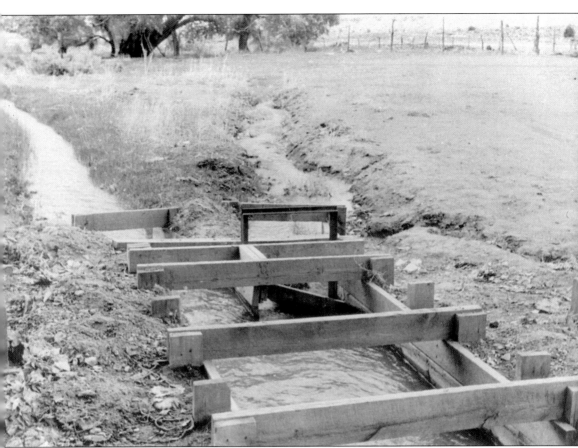

An irrigation headgate in Castle Valley is pictured in 1953. A vast web of ditches, gates, and streams woven together provided water to far-flung fields throughout Grand County. Many farmers were plagued by beavers, which used the irrigation canals to create easy ponds for their lodges.

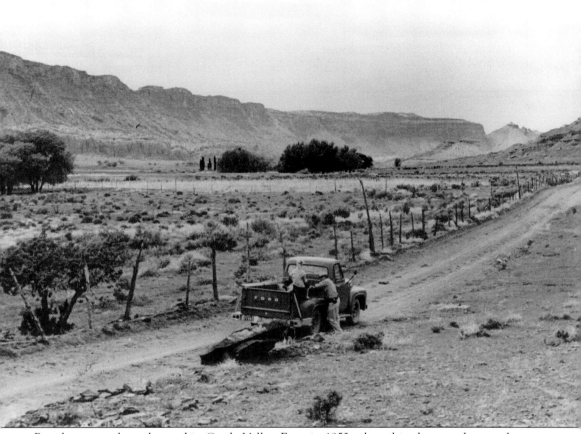

Ranchers stop along the road in Castle Valley. Even in 1953, when this photograph was taken, Castle Valley was still remote and sparsely settled. The Little Castle Valley was dominated by several large ranches owned by a few families. In the 1960s, ranches would be divided and sold off and the community of Castle Valley would begin to form.

A small group of horses are pictured in the horse corral at Titus Ranch around 1920. The Titus family settled in Professor Valley around the turn of the 1900s. Originally from Alabama, they migrated west to Texas, then New Mexico, before settling for a time in Monticello, Utah. For a short time, Professor Valley experienced a boom in settlement as farms and ranches were built along the Colorado River and Onion Creek, which flow through the valley. Over time, many families sold their ranches and moved into larger Grand County communities.

The Kane Springs Mail Station was a halfway stop between La Sal and Moab, providing a resting place from the heat of the day before travelers continued their trek through the red rocks between the two towns. Stops like the Kane Springs station were scattered over 10 to 15 miles along routes between communities to allow thirsty travelers and their mounts a chance to rest and gather supplies. Today, the routes of many of the roads of Grand County and San Juan County follow the trails between these way stations.

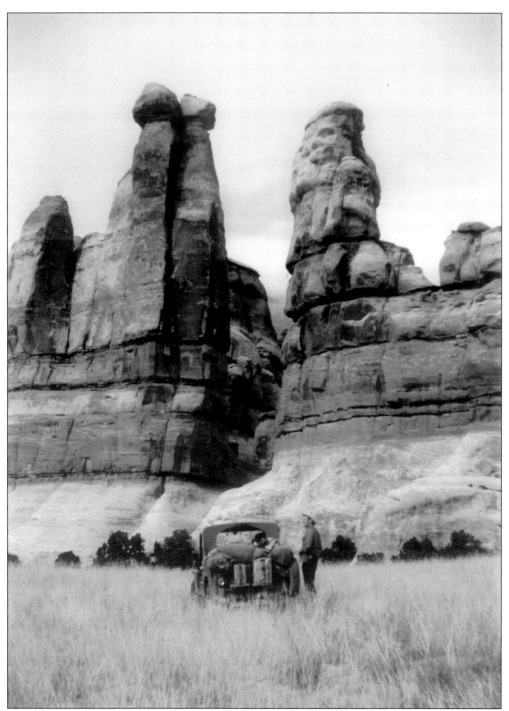

A ranch hand pauses in Chesler Park around 1958. Local cowboys claimed the name Chesler referred to a rancher who ran his cows in Canyonlands during the 1890s, but inscriptions near the site bear the name Shisler, which may reference a German immigrant who staked several gold claims during the miniature gold rush in southeastern Utah in the late 1800s. Chesler Park became part of Canyonlands National Park in 1964 when the park was established.

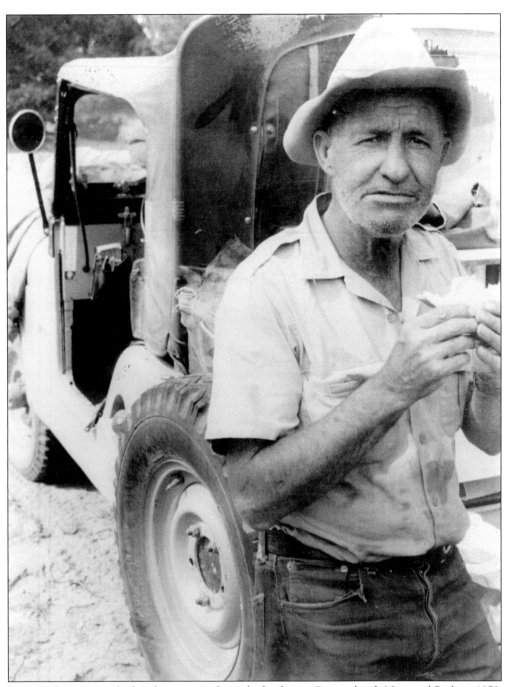

Bates Wilson pauses for lunch on a trip through the future Canyonlands National Park in 1959. Bates served as superintendent of Arches National Monument in the late 1950s. Looking to expand and create another park, the US National Park Service began soliciting suggestions for a new park. It was Wilson who suggested that the Needles Area, the Maze, and Island in the Sky be combined to create a new national park called Canyonlands. Wilson worked with a team of park service employees, Boy Scouts, and local Moab residents to map out, identify routes, and establish the area that would become Canyonlands National Park in 1964.

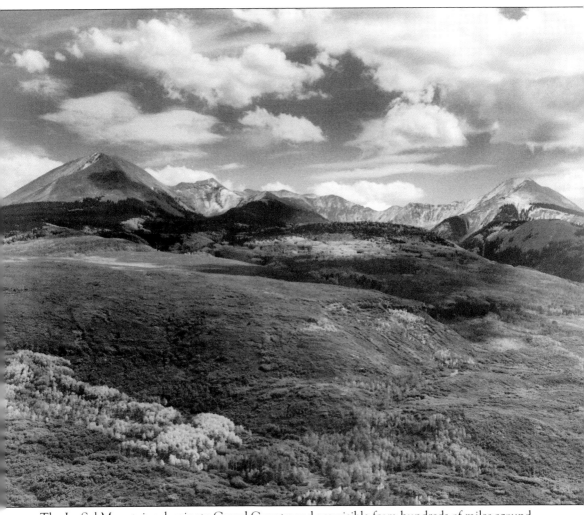

The La Sal Mountains dominate Grand County and are visible from hundreds of miles around. Mistaken by Mormon missionary setters as the Elk Mountains of Colorado, the La Sal Mountains were named by Mexican traders on the Old Spanish Trail. La Sal in Spanish means "the salt," a reference to the salt deposits in the area that were harvested by traders as they crossed Grand County on their way to New Mexico or California. Thrust up from the earth around 25 million years ago, the La Sals were formed by a volcanic intrusion beneath the sandstone layers of the earth. Wind, water, and ice carved away the sedimentary cap, revealing the igneous and metamorphic stone underneath. Glaciers and streams cut the distinctive peaks of the mountains and created the waterways and aquifers that provided water to the Moab, Castle, and Paradox Valleys surrounding the mountains.

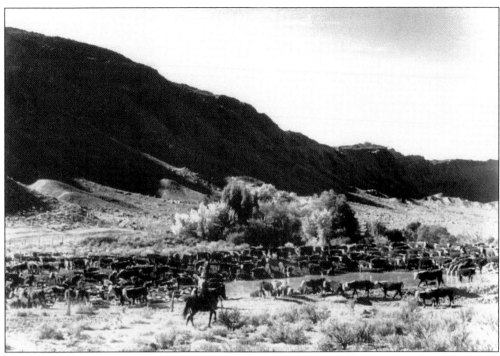

Scorup-Somerville Cattle Company workers drive cattle along the western side of the Moab Valley. It was one of the last cattle companies to push cattle through the Moab Valley toward Thompson Springs to the north. This drive took place in 1956, when Al Scorup led the cattle from his ranch near Indian Creek near La Sal through Moab. The drive stopped at the Grand Old Ranch House, and Moab residents were invited to have biscuits and beefsteaks. Millions of head of cattle passed through Moab throughout its 100-year ranching era. The transformation of Moab into a mining and milling community ended the majority of large cattle companies, whose workers chose to seek more lucrative employment in the mining industry.

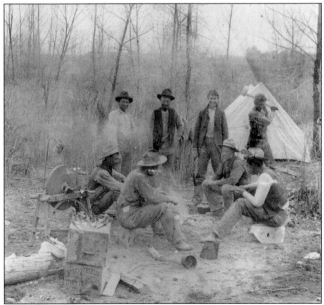

Shepherds are seated around a campfire near Cisco, Utah, around 1910. Gathered for the spring shearing, the shepherds are sharpening their shears on the whetstone. These shepherds are of Basque extraction. The Basque people of northern Spain have a long tradition of raising sheep in the highlands of the Pyrenees Mountains. With revolution in Spain during the early 1900s, many Basque men sought employment in America. Following the railroad, they eventually came to Grand County where they found large flocks of sheep and jobs.

Shepherds sit on wool sacks waiting for the Denver Rio Grande train to arrive in Thompson. Until 1934 and the introduction of the Taylor Grazing Act, Grand County hosted hundreds of thousands of sheep whose wool was shipped east to meet the demands of woolen mills on the East Coast. The huge sheep herds left their mark upon the land, and as the Dust Bowl raged in the Midwest, concerns over the fragile soil of the West led to the implementation of the Taylor Act, which limited herd sizes. Many sheep companies found themselves going bankrupt, unable to meet the demands of wool buyers due to their vastly reduced herds. After the delivery of wool in the spring, Thompson would hold an annual sheep-shearers ball, inviting the shepherds to spend their earnings and dance the night away with the ladies of Grand County.

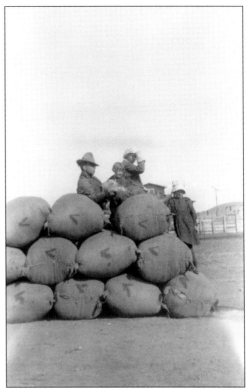

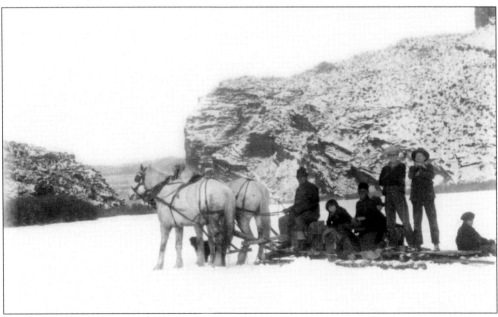

Members of the Westwood family sled on the ice of the frozen Colorado River around 1920. Until the 1950s, the Colorado River regularly froze over, allowing passage across the icy surface. The construction of dams along the river changed the flow of the river. Where once the waters near Moab were even and calm, allowing the formation of ice, today lower water levels break up ice flows and prevent the river from freezing over.

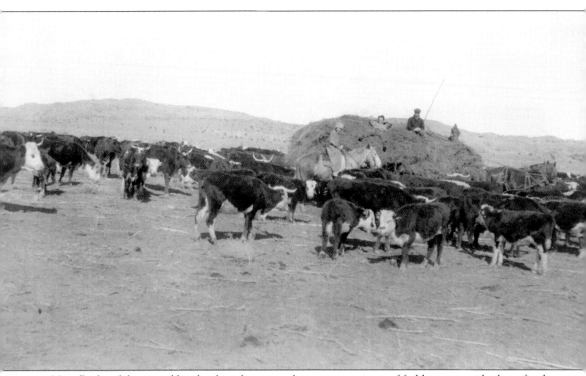

Vast flocks of sheep and herds of cattle required massive amounts of fodder to provide them food in both winter and summer. Grown along the riverbanks of Grand County, hay was transported to the cattle ranges. Even with the introduction of the automobile to Moab in the 1920s, the majority of hay was delivered by horse-drawn wagon, as pictured here in the 1920s.

Two

SURROUNDING COMMUNITIES

Some of the first settlers in Castle Valley, the Martins built homes and cabins on the west side of the valley. The Martins were in the valley during the battle at Pinhook Draw, and John Martin recounted hearing shots fired between the Native Americans and the settlers up the valley, but lacking good ammunition, he chose not to join the conflict. The Martins lived in Castle Valley until 1930, when they traded their land for a ranch near La Sal.

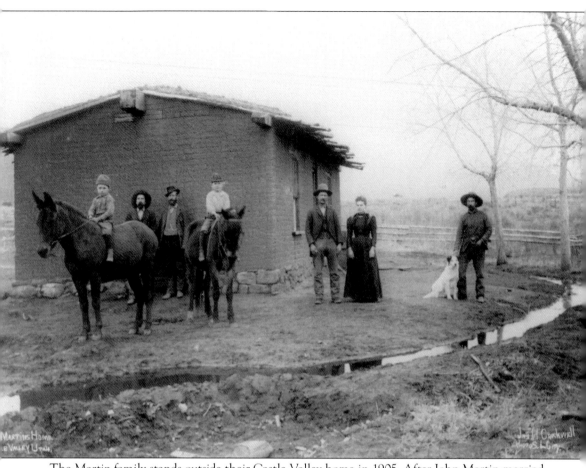

The Martin family stands outside their Castle Valley home in 1905. After John Martin married Cora Neeley, 30 years his younger, he began building this home in the lower end of Castle Valley. The home was built out of sun-dried and hand-pressed brick gathered from local sources. A quick solution for home building, sun-dried brick saved settlers time as the materials were readily available; however, the brick quickly deteriorated, necessitating its replacement with kiln-fired brick or sturdier timber homes. Over time, homes like the Martins', pictured here, were adapted to serve as parts of larger structures. Many homeowners have been surprised to find these smaller homes within their own walls while remodeling.

Matt Martin's was one of the first permanent structures in Castle Valley. The Martins had come to the Colorado Plateau from Iowa as miners looking to get rich in the silver strike of the 1880s, then as ranchers. The sturdy cabin built by Matt continued to be used into the 1960s.

Chester Wright, left, sits on horseback in Castleton. Located in the upper reaches of the Castle Valley, Castleton was an important connection to the outside world for miners with claims in the La Sal Mountains. Eventually, the town was abandoned after claims on the mountain played out. The grocery stores, hotels, and saloons were all abandoned. Time, fire, and general deterioration left only ruins of the once-thriving town. Chester Wright often played for dances in Castleton, which residents of Moab would travel to.

Castle Valley was originally called Little Castle Valley because it reminded settlers from Emery County of Castle Valley, where they had come from. These visitors to the Martin homestead posed for a quick photograph in the field around 1900. In the background, poplar trees wave in the wind. The quick-growing poplars were used to create windbreaks for orchards and farms, preventing the fresh-tilled soil from blowing away.

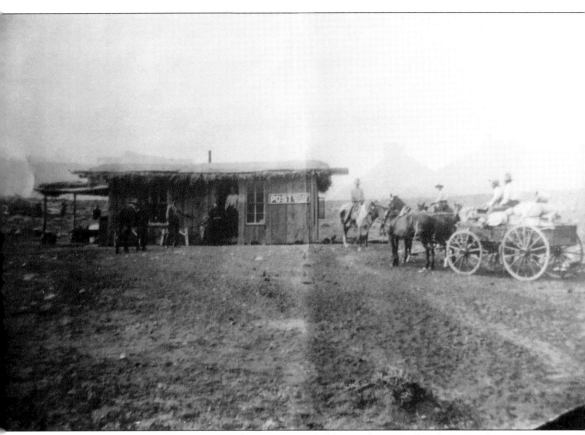

The Richardson Post Office is pictured in 1896. Settled by Professor Richardson in 1879, it was located along the Colorado River at the mouth of what is now called Professor Creek. As an important takeout point along the Colorado, the people of Richardson collected barges floated from Cisco and loaded goods for delivery to Castleton and Moab. The completion of Route 128 connecting Moab to Cisco by road and ferry spelled the end for Richardson, and in 1905, the post office closed its doors for good.

Abandoned foundation stones show the remains of a house in Castle Valley. In the background, the rock formation known as Round Mountain juts from the valley floor. Castle Valley was formed when a great dome of salt, laid down in the Mesozoic era some 200 million years ago, collapsed. That collapsed salt dome revealed the volcanic intrusion that is Round Mountain. This collapsed salt dome provided unique challenges to the settlers of Castle Valley as the wells they drilled were often full of salt brine. Those settlers who could find potable water flourished, while those who could not left only foundations like this one behind.

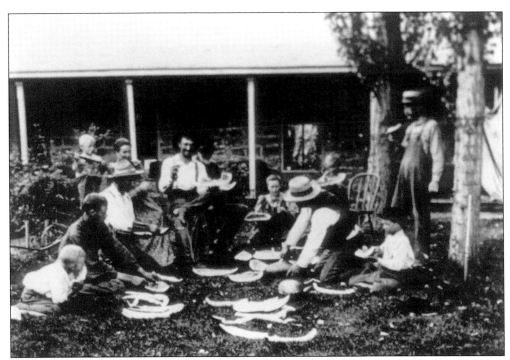

Pace family members eat watermelon served at a picnic on their ranch in Castle Valley. The Paces had settled in Castle Valley in 1888. The former resident of Payson, Utah, John E. Pace married Annie Sargeant in 1887 and then began plans to settle in Grand County. Pace served as one of Grand County's first representatives to the Utah legislature. He also worked tirelessly to raise money and hire laborers to build the river road connecting Moab to Castle Valley.

The Pace ranch in Castle Valley was well known for its cattle and abundant harvests. John Pace set up a store on his ranch as well, which provided dry goods and tools to the residents of Castle Valley, saving them the arduous 17-mile trip to Moab.

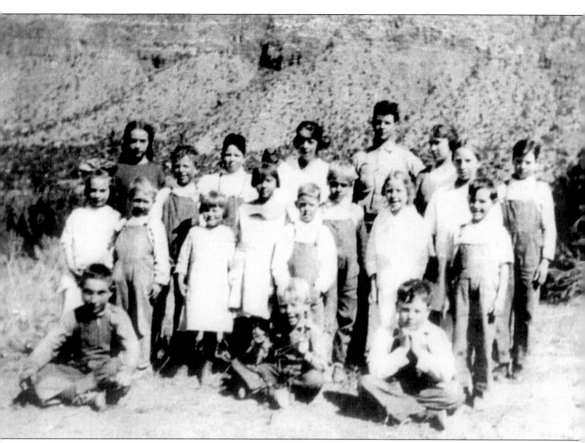

Students of the school in Castle Valley were photographed in 1918. A rancher in Castle Valley built a schoolhouse in 1893 to provide instruction for children. The first teacher was Arnold Aldrich (or Aldridge), whose family owned a ranch along the Colorado River. As roads between Moab and Castle Valley improved, students began attending school in Moab.

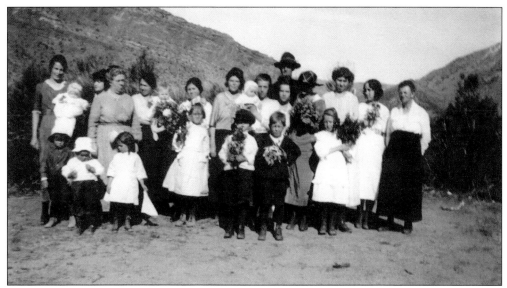

A Castle Valley family gathers to celebrate Memorial Day in the Castle Valley Cemetery in the early 1900s. Memorial Day was a relatively new holiday that had been created to honor deceased service members, especially those who had died in the Civil War. At the time when this photograph was taken, most residents of Utah called it Decoration Day and would spend spring days cleaning graves, weeding cemetery plots, and placing flowers. Flowers were often grown at home specifically for decorating and weddings. It would not be unusual to find a spring bride decorating the grave of a family member with flowers from her own wedding.

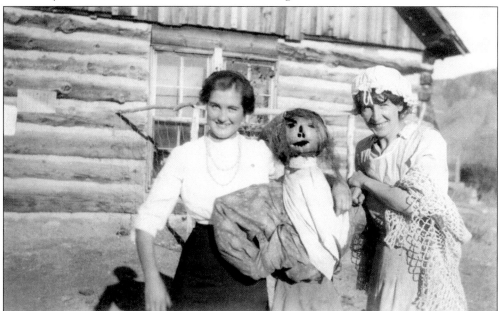

Hazel Edwards and Marie Fowler accompany a ghoulish scarecrow to the Castleton Halloween Party. In small communities like Castleton, holiday parties provided both regular entertainment and an opportunity for community members to get to know each other better. Many recent immigrants brought traditions like Halloween to the United States, and newspapers like the *Grand Valley Times*, later the *Times-Independent*, would publish articles on how to celebrate the holiday.

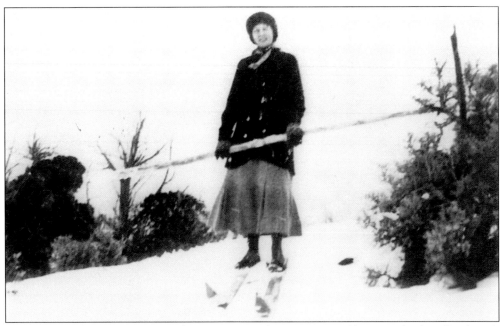

Castleton resident Mary McDavid enjoys winter fun on a pair of homemade skis. Castleton's elevation brought plenty of snow in the winter and allowed for many winter sports to be enjoyed by residents of the town. Skis had been brought to Utah by Nordic converts to the LDS church in the 1860s and 1870s and were adopted by many miners, trappers, and backcountry explorers. Over time, shorter skis for downhill activity developed from the long cross-country skis. In 1936, Brighton Ski Resort opened as Utah's first official resort. Though the La Sal Mountains often received generous snow, they only briefly hosted a ski area near the town of La Sal. Today, skiers and snowboarders brave the high mountains well into spring to enjoy snow recreation like Mary is enjoying here.

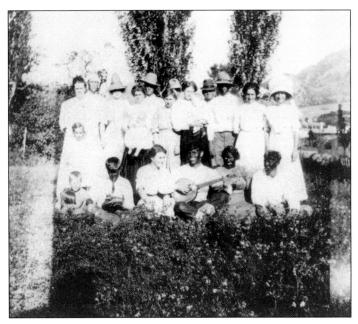

Children and young adults of Castleton gather to perform a minstrel show. These popular productions were often variety shows of local talents, tied together with a group of musicians who would paint their faces black to imitate African American musicians. Though meant to be fun, minstrel shows were often offensive in their depiction of African Americans and eventually became unpopular among the general American population, eventually vanishing from community functions.

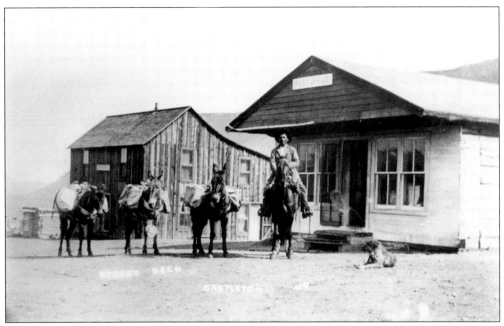

The Castleton Post Office is featured in this "Street Seen" by an unknown photographer sometime after 1900. Like many small communities, the establishment of a post office represented its transition from a small gathering of houses to a bona fide town. Castleton's post office opened its doors in 1900 in Lincoln Anteles's store, pictured here. Mail was delivered once a week from Moab by mule and wagon team.

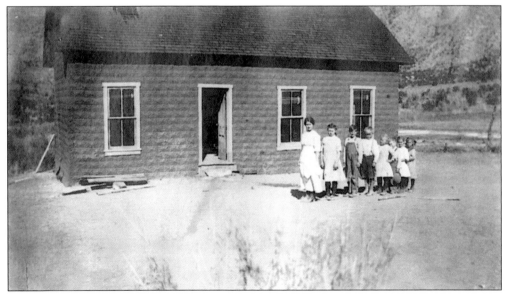

The students and teacher of the Castleton School line up tallest to smallest. Castleton's large schoolhouse had once served the town as a saloon. A teacher from Grand Junction, Colorado, established the school but eventually returned to Colorado, having decided the frontier town was too rough and tumble. She was replaced by Ida Wells. The students pictured here in 1904 included Jack Corbin, Daisy Davis, Veda Robertson, and members of the Denny family.

Dry-farming prospects in La Sal, Utah, drew many Moab residents south to the small town in hopes of homesteading a new community. This home pictured in the 1920s was one of many built in La Sal to house the new farmers who sought to make their fortune in the open spaces. Dry farming proved difficult as even the little water needed to manage a dry farm was scarce and distance made the sale of crops unprofitable. By the 1930s, most of the dry farmers had given up. It would not be until the 1960s, when uranium was found near La Sal, that the town would grow again.

More than just a feed store, the La Sal Live Stock & Store Company provided dry goods and tools, and even served as an outlet for catalog orders for the town of La Sal. Originally built 15 miles east of its present location, the town of La Sal gradually moved west to meet the needs of new farms, ranches, and mines. Eventually, the old town and the new town fully separated, leaving Old La Sal and New La Sal. This photograph, taken in 1925, shows that the residents still chose horseback over the newer, expensive automobiles. The conversion of wagon trails into roads was a slow process, and for many farmers it was easier to still use their horses even into the 1950s.

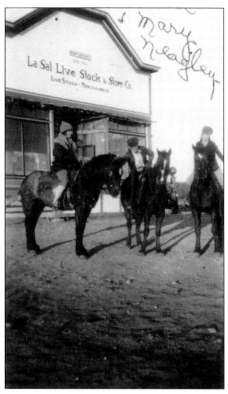

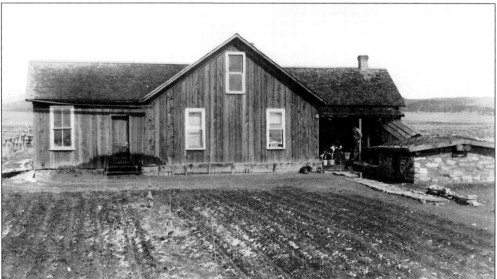

The Prewer home is pictured here in 1909. Early settlers of La Sal, formerly known as Coyote, Fred Prewer and his wife, Helen, built a home on the wide southern slopes of the La Sal Mountains. Fred had worked as a cowboy for the Pittsburg Cattle Company and was an original partner with the Cunningham and Carpenter Cattle Company before settling to farm in La Sal. Built out of sturdy timbers from the La Sal Mountains and stones gathered locally, the home was made to withstand harsh winters and windy springs. To the right is the root cellar that stored both vegetables and canned foods for the family in lieu of a refrigerator.

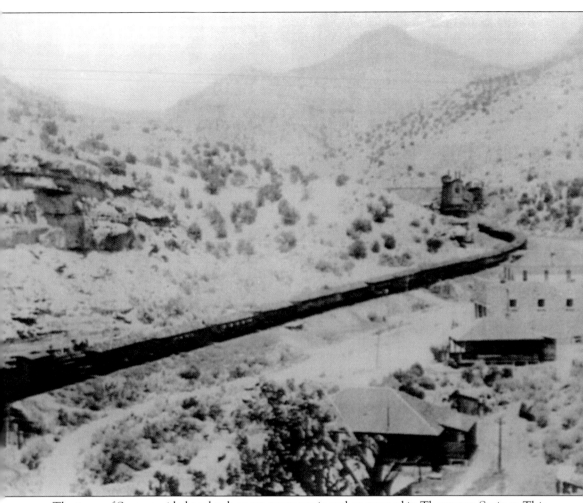

The town of Sego provided coal to hungry steam engines that stopped in Thompson Springs. This coal camp was named after Sego brand milk and was a company town. Workers were segregated by race and class. Common workers lived in a makeshift camp of tents and dugout houses, while company officers had houses built near the company store. Though prices at the company store were twice that of nearby Thompson, few miners had the means to travel the five miles south to enjoy better prices. Eventually the demand for coal from Sego ended and in 1947, the mines were officially closed. Today only the walls of the old store remain standing among the ruins of the company officers' homes.

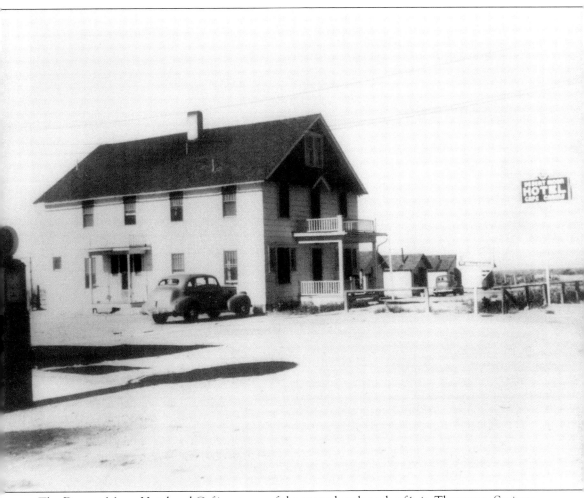

The Deseret Moon Hotel and Café was one of the many hotels and cafés in Thompson Springs that provided for travelers on Highways 50 and 6 and on the Denver & Rio Grande Railroad. The two-story hotel was one of the tallest buildings in Thompson. When rail service moved to Green River, many businesses and hotels in Thompson closed down, leaving a partial ghost town behind.

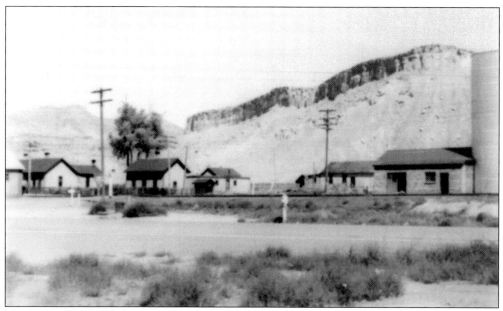

Named for E.W. Thomson, who built his home near springs at the mouth of Sego Canyon, Thompson Springs was a thriving rail stop on the Denver & Rio Grande. The railroad built its line between Denver and Salt Lake in the mid-1880s, first starting with a narrow-gauge line, then replacing it with standard gauge. Thompson provided ready access to coal reserves in Sego Canyon and water for boilers in the nearby springs. The town served as a hub of activities for shipping and commerce for Grand, Emery, Wayne, and San Juan Counties.

The Thompson Springs Hotel was built by Joe Taylor to accommodate the busy railroad town's many patrons. The original hotel, a two-story house, was enlarged with an extension to meet the demands for the overnight accommodation of travelers waiting for trains. On the far right sits the store also built by Taylor to provide supplies for the shepherds and cattlemen who stopped in Thompson. Near the store was a pool hall that gave many bored travelers an entertaining hour as they waited for the trains.

Howard Balsley snapped this photograph of some of the Thompson Springs bunkhouses, which were as close to a home as many ranch hands had when visiting the town. In spring and fall, Thompson Springs's population could swell to 10 times its normal size as cattle, sheep, wool, and other goods from Grand County were funneled to the railroad. Bunkhouses provided a little comfort and a place to sleep for those not willing to pay the steep prices of hotels.

Joe Taylor and his child wait in the garden in front of his hotel. Joe was one of the first settlers to bring large herds of sheep to the La Sal Mountains. Using his gains from the prosperous wool trade, Taylor was able to purchase land in Thompson and build his hotel and store. Taylor's Hotel was hailed as a sign of progress and modern life in Thompson and was admired by many who spent the night there. Eventually, the hotel was changed into a motel as travel changed from rail to automobile in the 1940s and 1950s

Les Roger stands ready to pump gas outside his parent's gas station in Thompson. Connecting Ocean City, Maryland, with Sacramento, California, Highway 50 was one of America's first great highways, built out of a network of trails, wagon paths, and roads. In 1926, "the 50" was designated through Grand County, and soon after Route 6—which connected Provincetown, Massachusetts, to Long Beach, California—was merged with the 50. While Route 6 had the distinguished title of "Grand Highway of the Republic," the 50 bore the honor of being the "Loneliest Road in America." The two highways ran right through Thompson Springs and gas stations like the Rogers' sprang up to meet the demands of cross-country travelers.

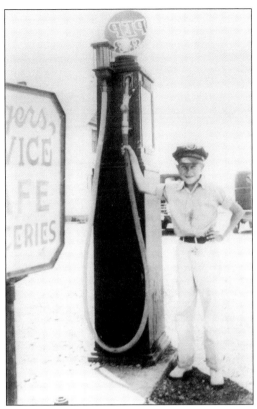

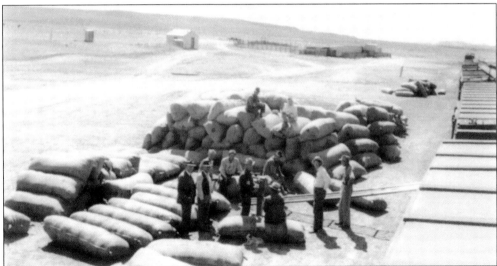

Shepherds and inspectors prepare to load bales of wool onto waiting railcars. Thompson Springs served as a hub for the wool industry in southeastern Utah. Sheep companies from up to 200 miles away would bring their wool to Thompson every spring to be sold to factories in the eastern United States. In the fall, thousands of sheep were brought to be sold as meat for winter. In the spring, the town would put on a sheep-shearers ball—a highlight in the county. Citizens from all parts of Grand County would come together to dance and celebrate a successful spring shearing season and spend some of their hard-earned money in the shops at Thompson.

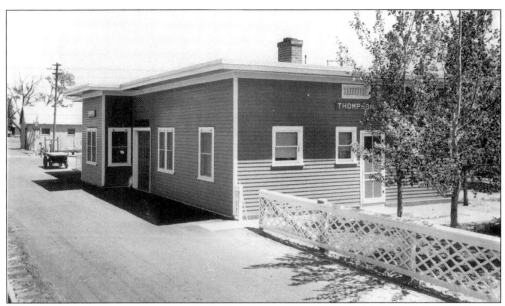

The modern Thompson Springs Train Station was built in the 1950s to meet the increased demand for access to Grand County after the uranium boom. The station served Thompson Springs and Grand County until the end of the boom, when the rail stop was moved to Green River.

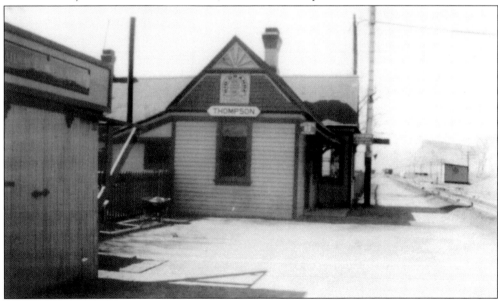

The Thompson Springs railroad station was built in the 1890s by the Denver & Rio Grande Railroad. The station was a lifeline between Grand County, the rest of the country, and the world. Young men shipped out of this station for World Wars I and II as well as other conflicts like the Korean War. Hundreds of couples left on honeymoons from the station, and thousands of young men and women left from here to attend college in larger cities. The station also oversaw the huge trade of cattle, sheep, copper, produce, and uranium shipped from Grand County to the world. While other rail towns in Grand County vanished over time, Thompson Springs thrived because of its connection to coal in Sego and a network of roads connecting it to destinations across eastern Utah.

Three

MOAB STREETS AND BUILDINGS

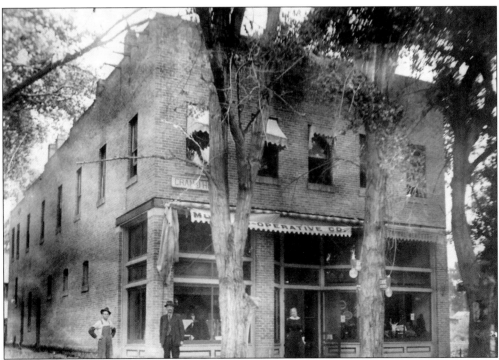

The Moab Co-op, located on the southeast corner of 100 North and Main Streets, was built in 1913 by ranchers and was managed by Ralph Miller Sr., who began running the store in 1930. The store almost disappeared during the Depression but survived through the reimbursements for welfare allotments from the government. Despite the lean times, the Millers introduced refrigeration to Moab and eventually built Moab's first cold locker, which allowed local stockmen to butcher their cattle locally and keep it cool. Sadly, the Moab Co-op burned to the ground along with the Grand Hotel that was located above the building.

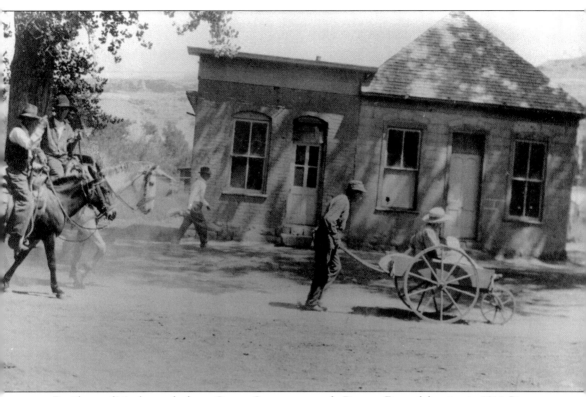

Residents of Moab parade down Center Street as part of a Pioneer Day celebration in 1914. Pioneer Day remembered the arrival of the first company of Latter-day Saint wagons to the Salt Lake Valley on July 24, 1847. Many of Moab's early residents arrived in Utah by crossing the Great Plains in wagons or pulling handcarts. Pioneer Day in Moab was celebrated with a large parade ending at a picnic at the City Park located south of Moab.

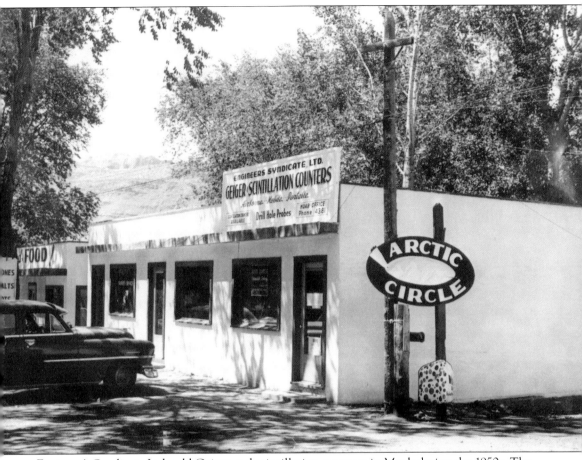

Engineer's Syndicate Ltd. sold Geiger and scintillation counters in Moab during the 1950s. The building had been an Arctic Circle restaurant but growing demand for prospecting supplies quickly convinced the owners to change their business model. The uranium boom brought floods of fortune-seekers who were eager to find their own million-dollar mine. The population of Moab boomed.

The First National Bank of Moab, on the corner of Center and Main Streets, was the first official bank opened in Moab. Founded by the owners of the Cooper-Martin Store in 1916, the bank opened with $50,000 in capital stock. Shortly thereafter, the Moab State Bank opened but quickly went bankrupt, as was common with many early banks in the West. The bank building also housed the *Times-Independent* newspaper, which later moved to a new building as the bank expanded.

Center Street in Moab appears empty in this photograph from the early 1900s. Lined with cottonwoods and other shade trees, early Moab was littered with leaves in the autumn. Deep canals on either side of the street provided irrigation water to numerous fields that dotted the community. Barely visible on the left is the Woodmen of the World hall, built by the fraternal organization. The hall burned down in the 1920s.

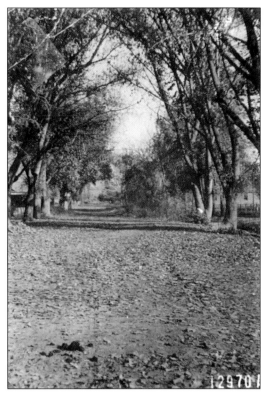

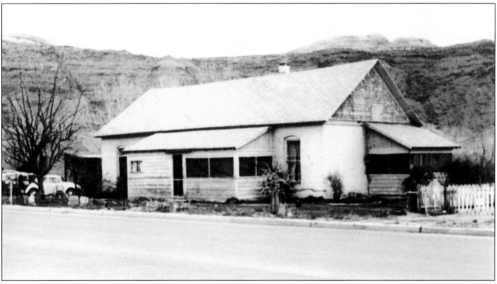

Cookingham Hall was Moab's second dance hall, built in the 1890s. Dancing was the most popular form of entertainment in Moab, and numerous balls and dances were held throughout the year. People of all ages would gather together regularly to dance and play music. Members of the community who could teach dance were held in high regard, especially recent immigrants who could bring styles from London and Paris. Cookingham Hall was eventually replaced by Star Hall, which hosted the majority of dances in Moab, while Cookingham Hall was converted into a private home owned by the Holyoak family.

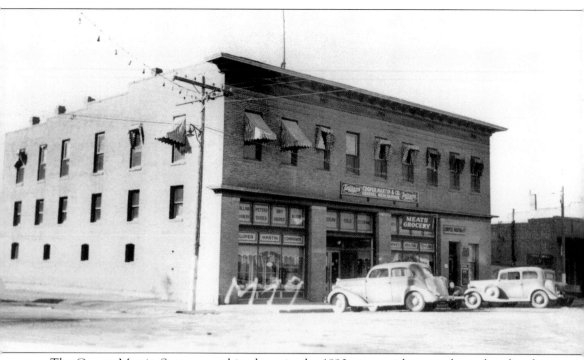

The Cooper-Martin Store opened its doors in the 1890s to provide general merchandise for Moab. The owners often boasted of having anything available anywhere in the world if one were willing to wait for it to arrive by catalog order. The store served as an early bank for Moab by taking deposits from stockmen and fruit growers and cashing checks. A center of commerce, the Cooper-Martin building competed with Hammond and Sons General Store for Moab's hard-earned dollars. Built out of sturdy kiln-fired bricks, the Cooper-Martin building weathered the 20th century well and continues to serve visitors to Moab.

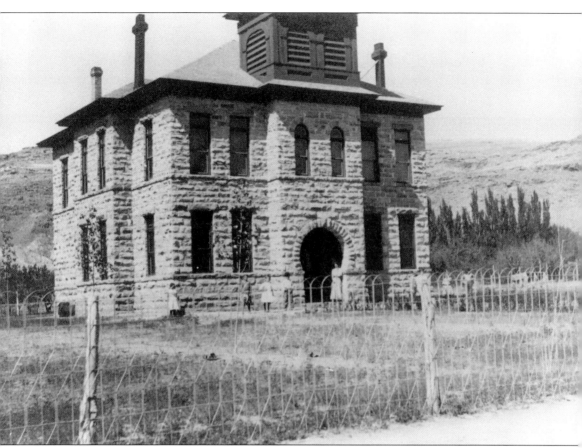

The Grand County Courthouse was built in 1903 out of red and white sandstone. The strikingly colored building was constructed for $10,000 by local masons who quarried the stone from around the Moab Valley and along the Colorado River. The courthouse was almost built in Castleton, which had a population that rivaled Moab's 300 souls, but was turned down as Moab rallied to gain support. Grand County was one of the richest counties in Utah because of its railroad and mineral wealth, but it had neglected to build a courthouse. The last county in Utah to build a courthouse, Grand County's was considered one of the finest in the state until 1937 when it was torn down to make way for the larger structure that stands in its place today.

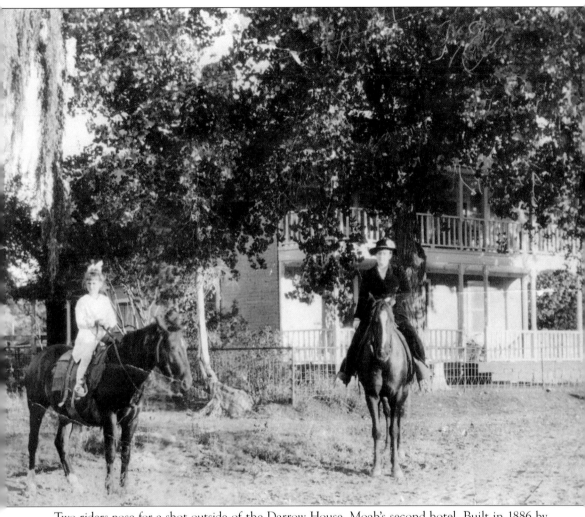

Two riders pose for a shot outside of the Darrow House, Moab's second hotel. Built in 1886 by Mark Darrow, the Darrow House Hotel was run by "Ma" Darrow, a corncob pipe–smoking woman whose hotel was so secure it served as a jailhouse from time to time. The building eventually was transformed into a private home but became a hotel again in the 1960s before it was torn down. It was also popular with several outlaws who were regular patrons.

Photographed in 1900, this building served many purposes including being a saloon for a short time. Dr. Williams used the red-sandstone-and-brick building as a location for his pharmacy and medical practice, as well as an outlet for his Studebaker wagon dealership. Williams was also a rancher and took time to collect Native American artifacts that he later donated to the US National Park Service.

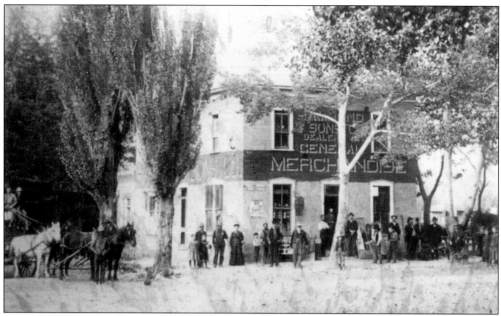

Fletcher B. Hammond built his mercantile store on the corner of 100 North and Main Streets in Moab. Opening its doors in 1896 under the name of Hammond and Sons, it was one of Moab's first successful businesses. The building has seen continuous use into the 21st century, though a fire in the 1970s left only the exterior walls. Joe Kingsly, owner of the building at the time, vowed to rebuild and eventually the building was restored and opened its doors again.

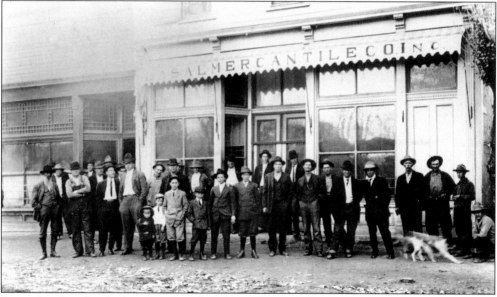

Dressed in their Sunday best, citizens of Moab stand in front of the La Sal Mercantile Co. Irritated with high prices charged by other shops in town, a group of ranchers pooled their resources and opened their own competing general goods store. The store was also the site of the murder of Jess Gibson, whose killer was never apprehended. The assassin had waited in the stairwell of the store, on the right side of the photograph, and when Gibson passed by, he fired. His aim was off and the bullet ricocheted off the door frame, but still struck Gibson.

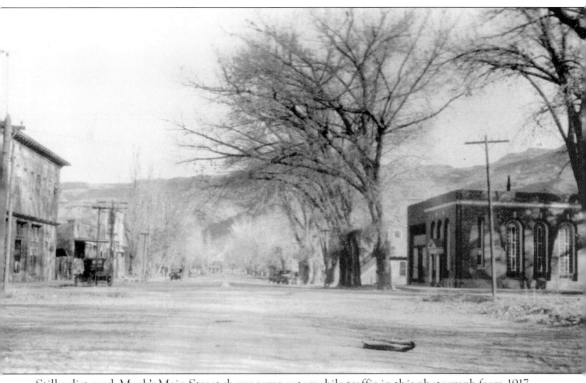

Still a dirt road, Moab's Main Street shows some automobile traffic in this photograph from 1917. Some of Moab's first electrical lines are visible. In 1914, Moab contracted the Moab Light and Power Company to provide electricity to the community. An early hydroelectric dam was built on Mill Creek. Flash flooding, common in Moab at the time, proved a challenge to the dam, washing the wood and metal structure away and leaving Moab without electricity for days and weeks. In 1919, a sturdy concrete dam ended Moab's blackout problems and allowed citizens to enjoy the convenience of electricity.

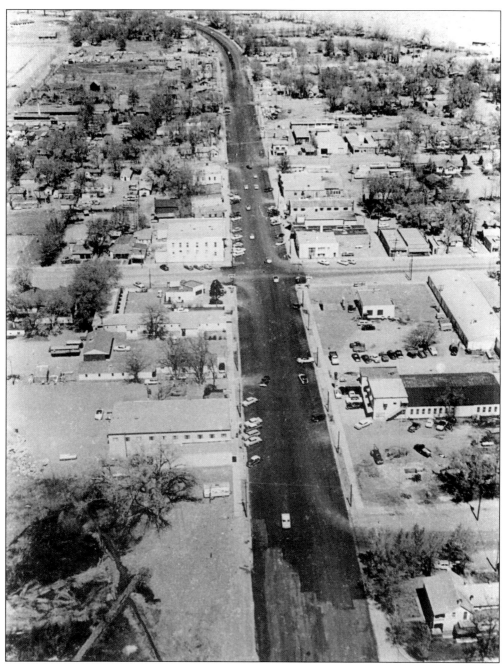

This aerial shot of Moab's Main Street, looking north, was taken in the late 1950s as Moab's uranium boom was reaching its peak. Scattered throughout the picture, tow-behind travel trailers serve as makeshift homes for many waiting for new homes to be built. Even Moab seems unfinished: 100 South Street in the foreground has yet to be completed and only the banks of Mill Creek are visible on the west side. Until the 1960s, the main route through Moab turned east on Center Street before heading south onto 400 East Street and down Spanish Valley Drive toward San Juan County. In the 1960s, the road was rerouted and a new bridge was built across Mill Creek providing access to the southern part of Moab.

Young men from the CCC head toward the gas station on the corner of Center and Main Streets. By the 1930s, Moab had removed many of the irrigation ditches along Main and Center Streets. In the background, the Woodmen of the World hall is still visible. The young men are from the CCC at Dalton Wells, north of Moab. On weekends, they would attend dances at the Woodmen of the World hall and movies at the Ides Theater. Mostly from other parts of the United States, many of the men decided to stay on in Moab after the end of the CCC and married local girls.

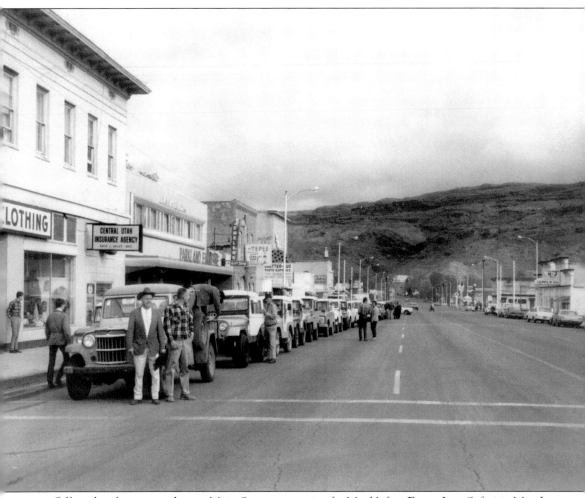

Off-road enthusiasts gather on Main Street, preparing for Moab's first Easter Jeep Safari in March 1967. Originally one trail ride with around 100 vehicles participating, the event has since grown to a weeklong event that brings thousands of visitors to Moab. Organized by the Moab Chamber of Commerce, the event took the party to Pritchett Canyon. Off-road vehicles had long been a part of Moab's history as they provided prospectors, ranchers, and explorers with easy access to the rugged backcountry of Grand County.

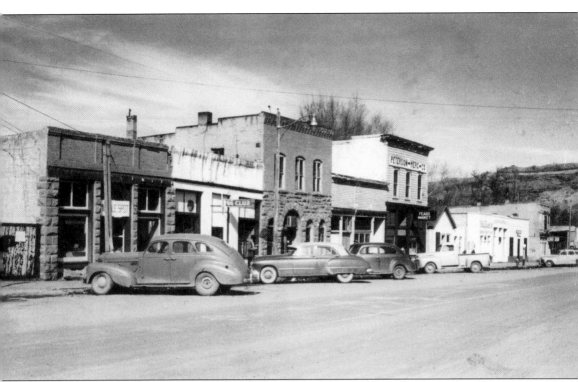

Moab's Main Street in the 1930s was a mixture of offices, stores, and bars, like many small towns in America. Many of these buildings had been built in the 1880s and survived to see new uses. While many other states struggled with the introduction of automobiles and the need to rebuild their infrastructure to meet the needs of parking, Utah had wide streets that had been designed for a team of oxen to be turned around in. This meant that as towns grew in Utah, parking was readily available for the explosion of affordable cars and trucks. These wide streets would also allow Moab to easily accommodate the army of ore trucks that would travel through town during the 1950s.

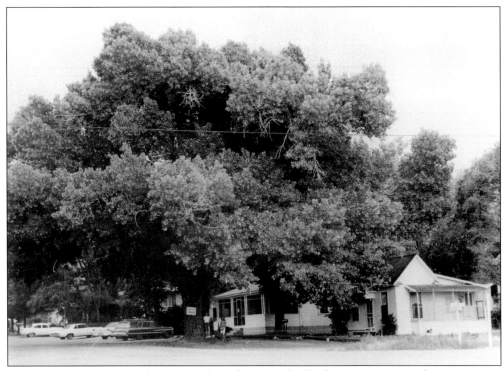

Moab's biggest cottonwood tree was planted in 1880 by Fred Stewart as one of many trees to surround his property. One of the oldest trees surviving in Moab, "the Old Cottonwood" was loved by many residents. When the city wanted to pave the road in front of the Stewart home, a campaign to save the tree arose, leading the Moab road department to divert the road around the majestic tree in the 1970s. Eventually, time and rot wore away at the tree, and it fell. It was originally located on 100 South Street near 300 East Street.

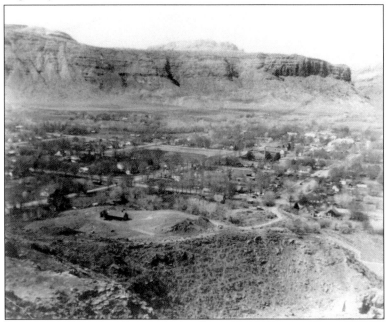

An athletic photographer climbed Legion Hill on the west side of Moab and took this picture of town in the 1920s. Moab was originally laid out on a grid system like many towns in Utah. The grid was modeled on one used to layout Nauvoo, Illinois. At center, one can see Central School and Star Hall across from the large field that would later become Moab's ballparks.

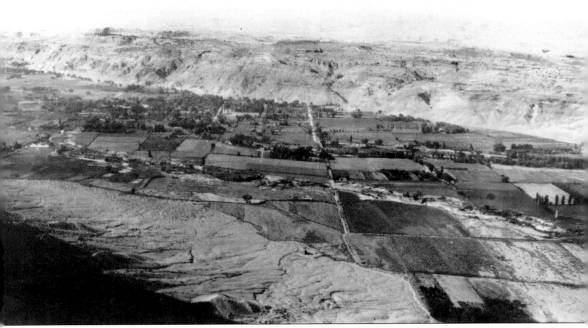

A patchwork of roads and farms fill the Moab Valley looking north from the Moab Rim. Though water from the La Sal Mountains was readily available, any land not irrigated by Moab's network of canals and ditches would quickly revert to desert. In this photograph, the difference is especially stark in the foreground where the line between fields and the arid untamed land is clearly visible. Running through the center of the photograph, Pack and Mill Creeks meet in the center of town. The confluence of the two creeks and numerous springs made Moab's location ideal, though floods along the creeks could back up into the streets and houses in town.

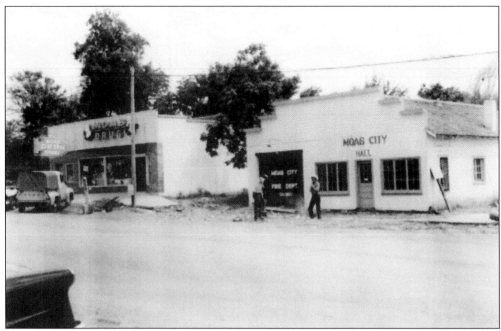

Moab City Hall and the fire department shared quarters in a small building located on Center Street across from the courthouse. The city used this building—which at one time had served as a mortuary—until the 1960s when new offices were built. Growth from the uranium boom forced Moab to expand its government, and this meant larger facilities. The old city hall was too small and eventually the land and the buildings were given to the Museum of Moab, which is on this spot today.

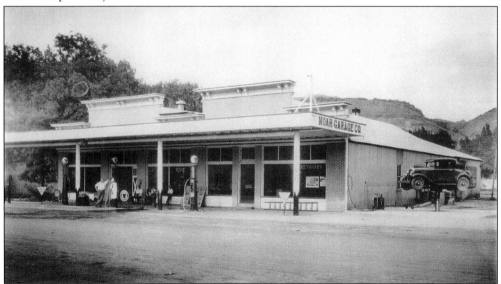

The first automobile to arrive in Moab came in the summer of 1909, driven by W.E. Cameron, who was heading west to Los Angeles to open a garage. Several garage companies started up in Moab, providing freight services and car repair. The Moab Garage, pictured here in the 1920s, provided gasoline, auto repair, and freight service for residents and visitors to Grand County. The Moab Garage also operated several boats on the Colorado River.

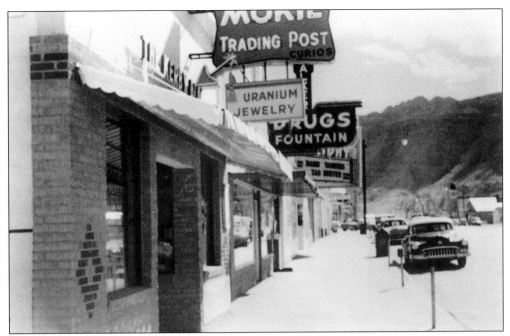

The Moki Trading Post was one of Moab's many early jewelry and tourist shops that grew up in the wake of the uranium boom. Pictured here in 1963, downtown Moab was growing and new shops and businesses were opening every day to meet the needs of not only local industry but a growing tourism trade that reemerged surrounding the national parks and Moab's uranium industry. The trading post also sold uranium-ore jewelry and cufflinks, which were quite popular with visitors.

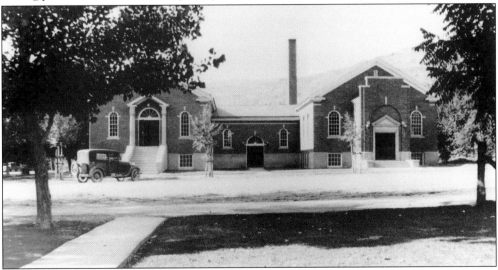

As Moab began to grow, so too did its religious congregations. By the 1920s, it was apparent that the small two-room church on Center Street would not be sufficient for the LDS congregation. Property was purchased on the corner of 100 North and 100 East Streets, and plans were laid to construct a new building. Following church-approved blueprints, the Mormon congregation raised money locally through donations, dances, and bake sales to pay for the new structure. The building included rooms for Sunday school classes, a large chapel meeting hall, and a recreation hall for dances, plays, and basketball. This photograph was taken in 1926 sometime after the building's completion.

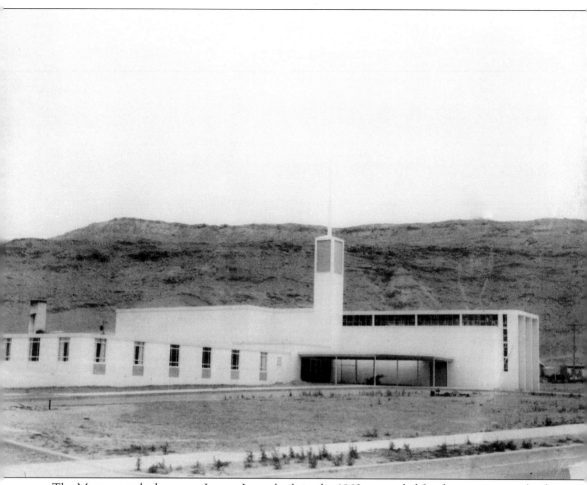

The Mormon stake house on Locust Lane, built in the 1960s, provided for the growing needs of Moab's LDS population. The large, cinder-block building was not the only church to be built at the time—Catholic, Baptist, Lutheran, and other congregations all built new churches as Moab grew exponentially. The stake building was built to hold several congregations and administrative offices as well as a large basketball court and stage.

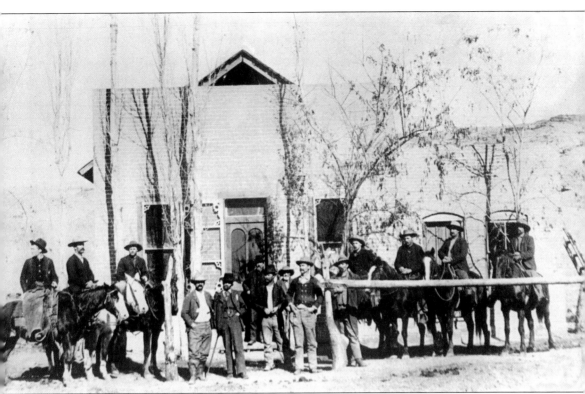

Local businessmen gather outside Tet's Saloon at the north end of Main Street. Photographed in 1890, the building was destroyed as Main Street was extended north toward the Colorado River. While Moab was not renowned for its saloons, it provided for the needs of its thirsty citizens. Today, Mormons are known for their avoidance of alcohol; until the 1930s, consumption of alcohol was not strictly forbidden among the faithful. While Prohibition killed off many Moab saloons, bootleggers used remote stills and river water to brew their own beverages and provide for Moab's demand for liquor.

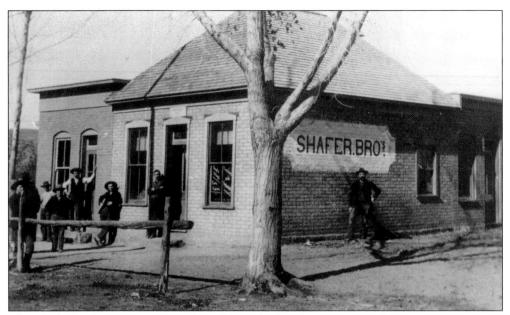

The Shafer brothers were early settlers who made their living in Grand County as carpenters. They also built caskets, cut hair, and hauled freight to support their income. Located on the corner of 100 East and Center Streets, their building was eventually sold to the Midland Telephone Company in 1925. The first switchboard was carried by hand from the Cooper-Martin building on the corner of Main and Center Streets to the Shafer building. The building served as a hub of Moab's telephone communication for many years. Eventually, as need increased, the building was expanded, and the original building was enveloped by the newer building.

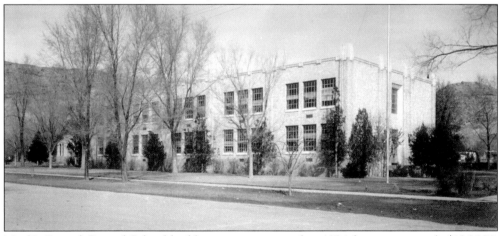

Moab's Second Central School building was constructed in 1934 for approximately $136,000. The two-story building contained 20 classrooms and a gymnasium designed to be as fireproof as possible. Until 1954, all 12 grades were housed in the building, but as the uranium boom caused Moab's population to grow, the school was forced to divide students into shifts. Morning, midday, and evening tracks allowed the hundreds of new children arriving in Moab to receive an education. Even with three tracks of school, many classes were so large that students had to share desks. Special efforts were made to ensure that each child received a hot lunch, since for many of the recent students, that might have been the only cooked meal they received. Today, the building is used by the city of Moab to house offices.

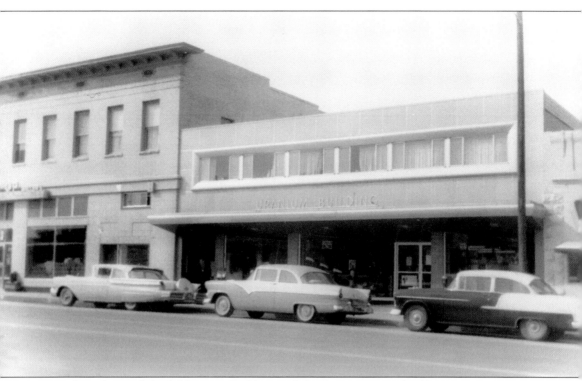

Pictured are the newly built Uranium Building and the Cooper-Martin building on Main Street in the late 1950s. Growth meant that many new buildings were needed, and the uranium building was one of the first to provide both office space above and retail below. Juxtaposed next to the Cooper-Martin building, the uranium building shows how Moab's transformation from sleepy agriculture town to booming mining town brought a great deal of change to Grand County. Built by Ralph Miller, owner of the Cooper-Martin building, the uranium building provided a needed addition as his grocery and dry goods business continued to grow through the 1950s. Miller was so successful that he eventually retired in the 1960s and opened a chicken ranch that was built into the cliff along the Colorado River.

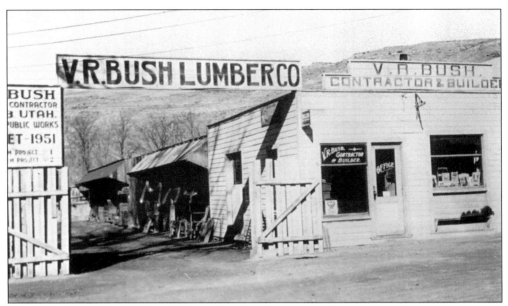

The V.R. Bush Lumber Company, located on 100 North between Main and 100 East Streets, provided many Grand County residents with lumber and hardware to build their homes. The Bush Lumber Company also built many of the bungalow-style homes found in Moab. This photograph from the 1930s shows the lumberyard and the contractor's office as well as the main store area.

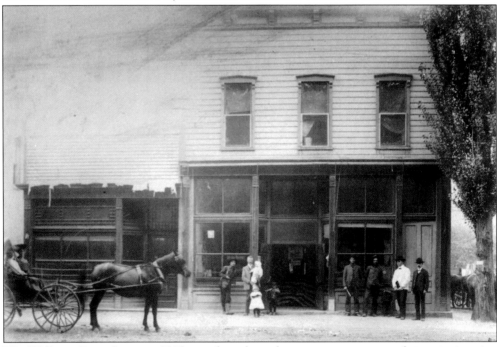

The Williams Drug Store, in 1905, stands with its doors open, giving a peek into its interior. Williams sold not only medicine but also Navajo rugs and Native American art. Williams additionally ran a Studebaker wagon and buggy dealership. As a doctor, he attended to patients as far south as Monticello, west to Hanksville, north into the Book Cliffs, and east to Grand Junction, all on horseback.

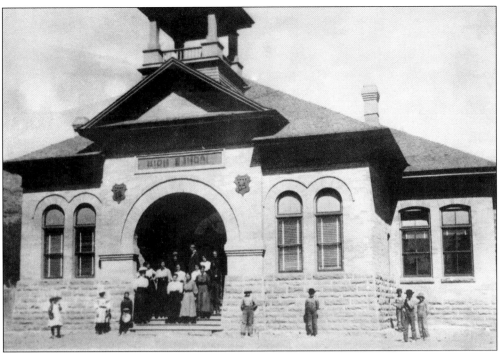

Moab's first high school was built in 1904 as the student body outgrew the old Central School. The high school had several classrooms and a small auditorium. When Central School was replaced in the 1930s, the high school was transformed into a public library. A fire in 1967 ended the life of the old high school, though all the library books were saved before it collapsed on itself. Eventually, it was replaced by a gymnasium that still stands on the location.

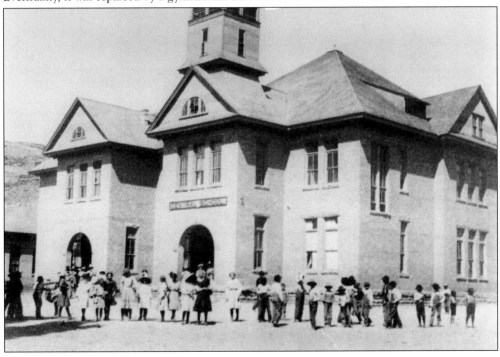

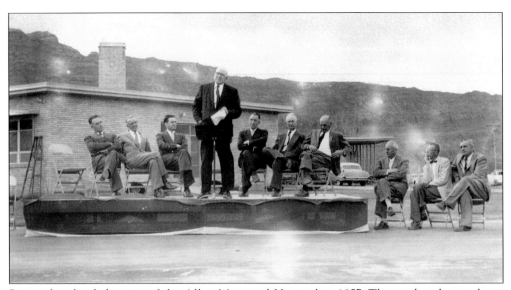

Pictured is the dedication of the Allen Memorial Hospital in 1957. The modern hospital was built on the west side of Moab, where more land was available and where patients could escape the sounds of trucks. The hospital boasted state-of-the-art equipment and was carefully designed so that each patient would be able to enjoy the fine views of the Moab Valley. Named for doctor I.W. Allen, the hospital operated until 2011, when a new one was built to replace it.

A workman builds Moab's new Community Church in the late 1950s. Built on land gifted to the church by Charlie Steen, the Community Church was one of many congregations to benefit from the Steen family's generosity. Recognizing the need to provide houses of worship for many of his workers, Steen allotted a portion of land he had purchased to build homes for his employees and for the construction of several churches. The land was nicknamed "Steen-ville" and was located north of 400 North and east of 500 West Streets in Moab.

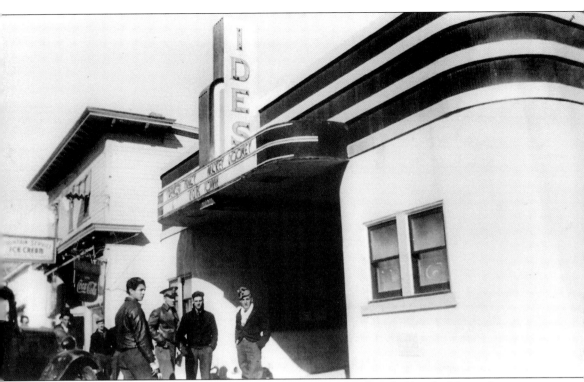

The Ides Theater on Main Street brought cinema to Moab. Though films had been shown in Star Hall and the Woodsmen of the World hall from time to time, the Ides was the first full-time cinema. Here, in 1937, a group of young men from the Civilian Conservation Corps waits to attend a showing of *Boys Town*. Opened by the Clark family in the mid-1930s, the theater's name referred to the Ides of March, when the theater first opened its doors on a windy, rainy day. Sound for the films was played on a player piano that was constantly pumped throughout the film. When talking movies came about, a phonograph was used to bring the actors' voices to the film, though often it was difficult to synchronize the film and the audio track. The Clark family sold the Ides during the uranium boom.

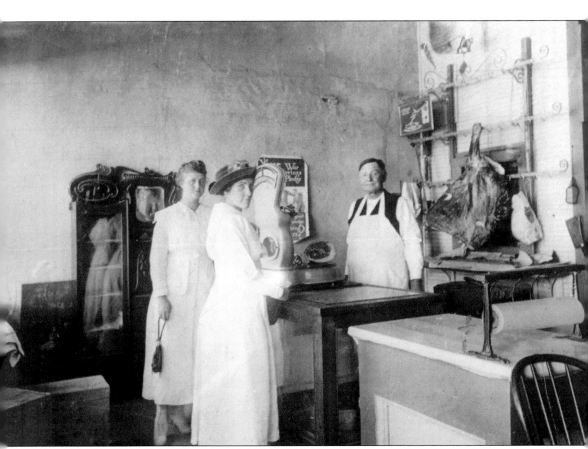

Inside the Hammond and Sons General Mercantile Store, patrons who ordered a ham are served by Mr. Hammond in 1918. While also providing dry goods, Hammond and Sons butchered and prepared meat that they kept cool with ice from the local icehouse. Refrigeration would not arrive in Moab until the 1930s, when Moab Co-op Store owner Ralph Miller installed the first display refrigerator and a walk-in freezer in the building. Ice for the local icehouse was collected from the Colorado River and stored in a deep dugout under straw and other materials to insulate it against the heat of summer.

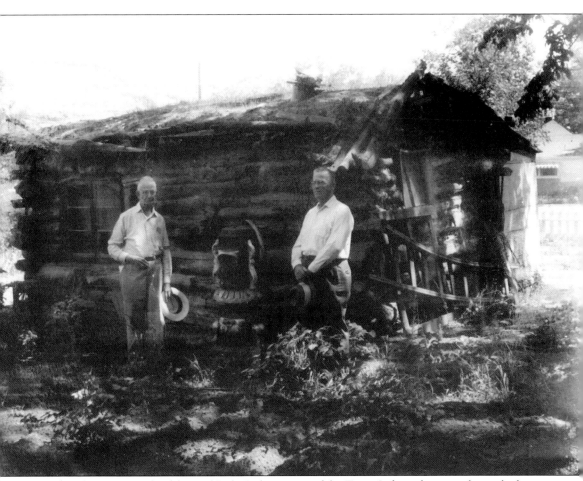

Local geologist Howard Balsley and Bish Taylor, owner of the *Times-Independent*, stand outside the Balsley Cabin. The Balsley family had originally arrived in Utah to build a home in Valley City, located 25 miles north of Moab, but ultimately chose to move into Moab. This cabin belonged to Balsley for a time and was built in traditional pioneer fashion out of split logs and adobe mud. Straw mud and clay provided the roof, which was set across cottonwood beams. Drafty in the winter and boiling in the summer, the early cabins nevertheless provided some protection from the elements. Balsley's cabin was preserved by the Daughters of the Utah Pioneers Grand County Chapter and can be seen near the chapter's museum today.

The Maxwell House Hotel was the first hotel built in Moab. Located on the southwest corner of 100 North and Main Streets, the three-story building provided lodging for visitors. Built by Philander Maxwell in 1885, his wife, Addie, ran the hotel and adjacent millinery shop until the hotel burned down.

The Utah Motor Court was one of the many motels that sprang up in Moab during the 1950s and 1960s. As the "road trip" of the 1950s began to catch on, Moab became a popular location for visitors as it was only a short drive from Highways 6 and 50, and it provided an easy jumping off point to Arches National Monument and Monument Valley. Early tourism was a small part of the Moab economy, and during the uranium boom, many hotels doubled as apartments for the newly arrived. The hotels also provided needed housing for many of the Hollywood film crews who came to Grand County to shoot Western movies.

Four

PEOPLE OF MOAB

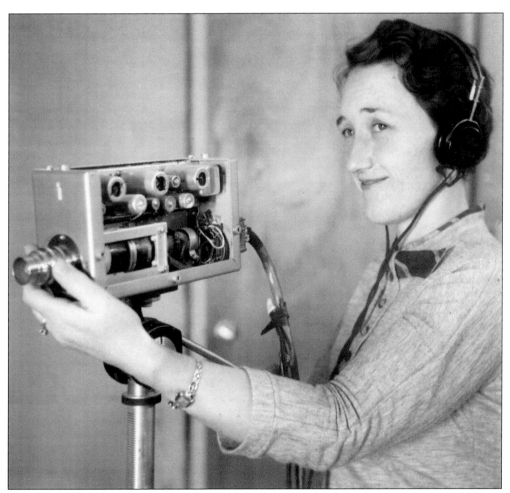

Ellen Alger films the evening news with her camera at Moab's first television station in 1957. As television spread across the country, it had difficulty reaching Moab as the high valley walls deflected transmissions. In the 1950s, enterprising Moab business owners formed the Moab Broadcasting and Television Corporation (MBTC). Ellen Alger was an investor, corporation secretary, and camera operator, and the transmission tower stood on a field that her family owned.

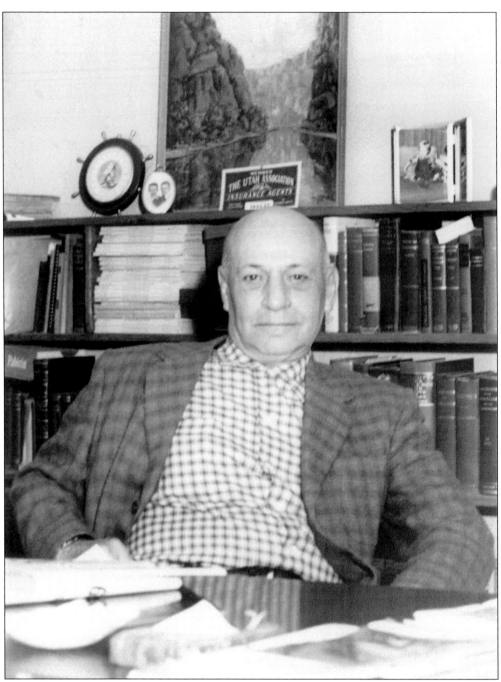

Dr. Isaac Walter Allen takes a rest in his office. Allen studied medicine at the University of Utah in Salt Lake City and at Rush Medical College in Chicago. He arrived in Moab in 1920 and took over the small four-room hospital on the corner of 100 West and Center Streets. Under Dr. Allen's guidance, the small hospital grew from a country hospital to a vibrant operation able to handle nearly any emergency. Dr. Allen married Dorothy Kirk, who passed away in 1928. Allen later remarried Daisy Davis Taylor. Because of Dr. Allen's dedication to Moab, when a new medical hospital was built in the 1950s, it was named after him.

Local eccentric Aaron Andrews leads his donkeys and mules on a parade through Moab in the 1930s. Andrews arrived in Moab from parts unknown and lived and worked with the Parriott family on their ranch. In his spare time, Aaron took to sculpting in the sandstone north of Moab and parading his animals up and down Main Street in mock military style. A skilled artist, Andrews created numerous medallions that he gave to friends or bedecked on himself and his animals.

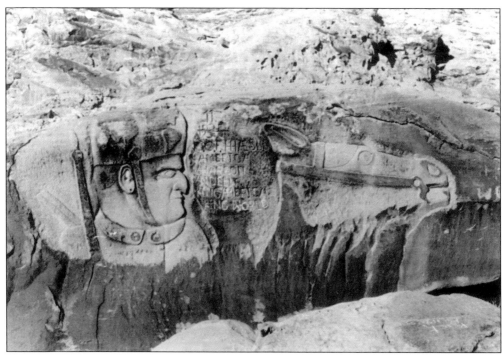

No one is quite sure about the meaning of Aaron Andrews's mysterious drawing of a horse and world-crowned rider. It seems to denote Andrews as "king of the world," but the true interpretation was known only to Andrews. His eccentricities led to his eventual removal from Moab and his committal to the Utah State Mental Hospital in Provo.

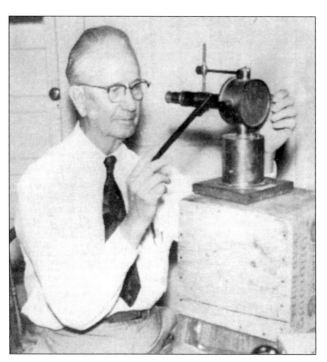

Howard Balsley demonstrates the use of an electroscope to assay uranium ore. Often called the "father of uranium" in Moab, Balsley was a prospector who arrived around the turn of the 20th century. After purchasing land in Grand County, he began working for Judge Bartlett and eventually the forest service. After serving as Moab county clerk and auditor, he retired to pursue the mining, purchasing, and selling of uranium ore. Balsley lent money in the form of "grubstakes" to many prospectors, which were paid when their claim paid out. He worked tirelessly for miners' rights and was involved in several antitrust cases to protect the rights of Utah miners from corporations.

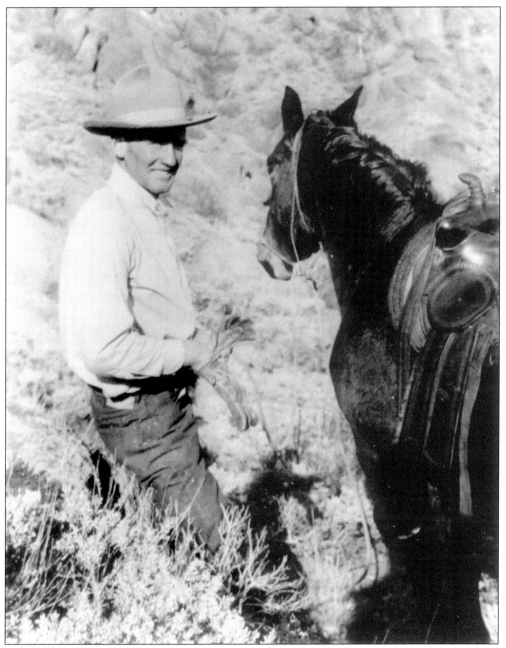

Bill Boulden dismounts from his horse Frank for a rest during a cattle drive. Boulden ran cattle on the La Sals until the 1980s, when he retired. Originally from Kansas, Boulden's family moved to Delta, Colorado, in 1917. When he was older, he came to Grand County and worked for Amasa Larsen in Fisher Valley. After serving in World War II, Boulden returned to Moab and started a ranch along the Colorado River at the present location of the Sorrel River Ranch near the entrance to Castle Valley, bringing his wife, Lillian, whom he had met in Corpus Christi, Texas. A successful rancher, he later served as chairman of the Grand County Commission, as a member of the Selective Service board, as part of the soil conservation district, director for the Eastern Utah Cattlemen's Association, and on the board of the Museum of Moab.

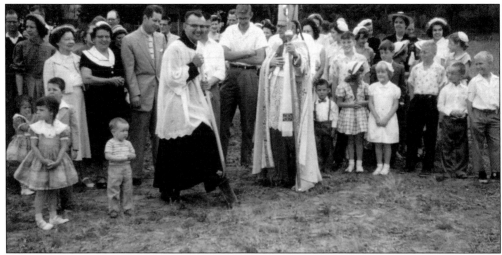

Members of the Catholic faith and the Salt Lake City diocese break ground for the construction of St. Pius X Catholic Church on 400 North Street. Though many Catholics made their home in Moab, a church was not built until May 1955. So eager were the members of the congregation for a church, they designed and erected the building themselves. According to one story, the builders forgot to include a heating system, which by the winter was quickly installed.

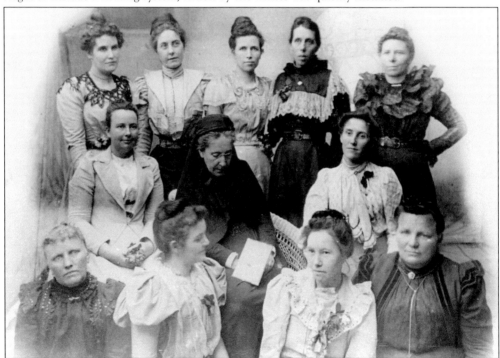

Moab's Busy Women's Club provided service and education for the population of Grand County. The founding members posed here in 1898 during their first meeting, when they studied Alaska. The club met together to read, study, and discuss topics such as history, geography, literature, and current events. In 1914, they changed their name to the Women's Literary Club. Supporting many community programs, they worked to raise money for numerous charities and were among the founding members of the Museum of Moab, providing the first start-up money to open its doors in 1958.

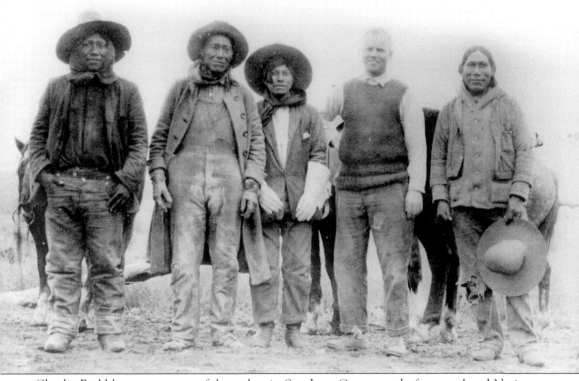

Charlie Redd became a successful rancher in San Juan County and often employed Native Americans as cowboys, as shown in this photograph. Born in Bluff, Utah, Redd later attended high school in Provo before returning to San Juan County to manage the newly formed La Sal Livestock Company around 1915. Eventually becoming full owner of the company, Redd also opened a store in La Sal and served as postmaster for many years. Active in politics and promoting the cattle industry, Redd was also named to the Order of the British Empire by Queen Elizabeth II for his services and friendship with Great Britain.

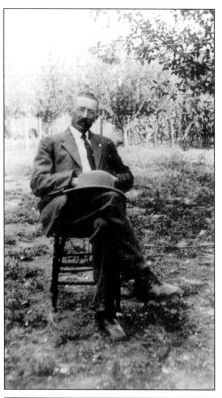

Enjoying a summer afternoon, Justus N. Corbin sits in the orchard outside his home. A pioneer in media communication, Corbin helped establish Moab's first newspaper, the *Grand Valley Times*, in the 1880s, later the *Times-Independent*. After his time as a paper man, Corbin worked to establish some of the first telephone systems in the West, connecting Moab to Monticello and Mack, Colorado, to Green River, Utah. Corbin put in many of the first telephone lines on horseback. An organizer of the Midland Telephone Company, Corbin brought modern communication to Moab.

As a small community on the frontier, new residents were welcomed with open arms. But as Moab grew during the 1950s, the number of newcomers made it hard for everyone to get to know each other. An enterprising Moab woman convinced local businesses to help her form a "Newcomers Club" as a way for locals to introduce their products to new people arriving in the community. This Newcomers dance was held as an open social. Newcomers to the community received a welcome package from local businesses that included a six-month free subscription to the *Times-Independent*.

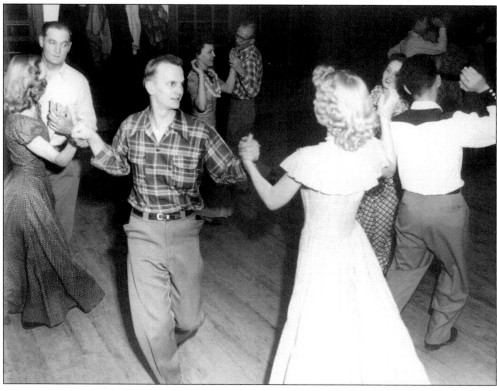

In 1919, Stone Rutledge (right), through an arrangement with the Bureau of Fisheries, introduced channel catfish into the Colorado River. Later, Utah officials, in the hopes of introducing catfish elsewhere in the state, paid 25¢ to 50¢ per small fish that could be caught and shipped to state fish hatcheries. In this photograph, Mart Fish helps Rutledge with the fish planting.

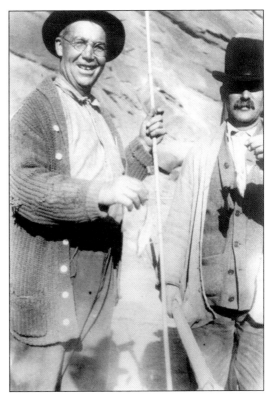

Martha Anna Wilcox Westwood Foy was the wife of Richard Westwood, Moab's longtime sheriff who was killed in 1929. For many years, Martha lived in the small community of Dewey between Cisco and Castle Valley. Her husband operated a ferry at the location, and Martha ran a small hotel that provided travelers a place to rest. When the Dewey Bridge was built in 1914, the town of Dewey vanished as travelers drove straight through to Cisco. After Martha's husband died she remarried, taking the name Foy.

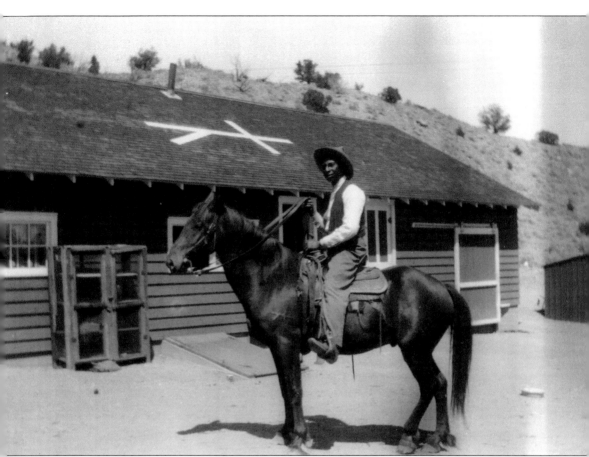

Charlie Glass was an African American cowboy from Kansas who settled in Grand County. Son of outlaw Dick Glass, Charlie always carried a pistol in case he was ever jumped. Well known in both Moab and Grand Junction, Charlie worked for several cattle companies. Here, he is mounted in front of the Cunningham ranch house where he worked at the time. Unlike communities in other parts of the country that looked down on certain ethnic groups, Grand County worked to include many people from different races and cultures. Charlie was well known for a standoff with Felix Jesui, a Basque shepherd, after Charlie caught him grazing sheep on his boss's land. Felix fired at Charlie with a rifle but missed, forcing Charlie to shoot him. Killing Felix would ultimately lead to Charlie's death when, years later, Felix's kinsmen attacked him near Cisco, Utah. Charlie was buried in the white section of the Fruita County Cemetery.

Henry Grimm was known for having a vicious temper. As the town blacksmith, he was known for chucking his tools out of his shop and into a nearby field, which became known as "Monkey Wrench Field." With his wife, Louisa, he ran Moab's only blacksmith shop for many years. The shop also boasted Moab's first electric lights, which were powered by nearby Mill Creek in 1901.

If one needed to catch a ride to Moab in the early 1900s, it was likely that Dale Parriott provided it. Parriott's family had settled in Castle Valley in the 1880s, but Parriott eventually moved to Moab and opened up a car and freight service. For many years, he made the trip between Thompson Springs and Moab regularly bringing freight and passengers to town.

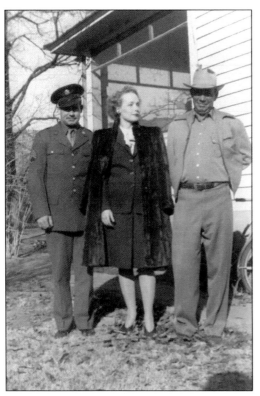

The Kirk family had come to Moab from Colorado at the end at the 1800s. Settling near Indian Creek, south of Moab, Rensselaer Lee Kirk eventually moved to Moab and began running cattle on the La Sal Mountains and sheep in the Book Cliffs. His wife, Helen, was one of Moab's first schoolteachers. The Kirks' home on 100 South Street near 300 West Street in Moab often hosted fundraisers. Here R.L "Buck" Kirk Jr. and his wife, Neva, stand in front of the Kirk home in 1944. The Kirks were also good friends with cowboy Charlie Glass, who visited the family whenever he was in Moab.

Helen M. Knight graduated from the University of Utah in 1917 and began teaching in Grand County that same year. Helen was a member of the Taylor family, which was among the first families to permanently settle in Grand County. As a teacher, Helen began a courtship with Edward Knight but kept their relationship secret for fear she would lose her job. When they finally were married in 1932, Helen not only kept her job but went on to become the superintendent of schools for Grand County in 1936.

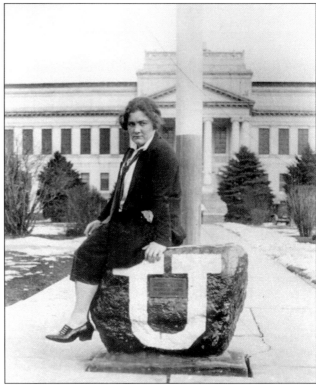

Beloved by many, Helen M. Knight was honored in 1955 with the naming of Moab's new elementary school. She was a dedicated superintendent and traveled many of Grand County's dusty roads to assure that children throughout the area were receiving the best education possible. As the uranium boom brought hundreds more students to the community, Knight was one of their first advocates working to protect the numerous children whose parents had arrived in Moab penniless and hoping to get work. Under her careful guidance, the school district expanded, building a new high school and two elementary schools. Retiring in 1961, Knight continued to further learning in the community by serving on the Museum of Moab board of directors.

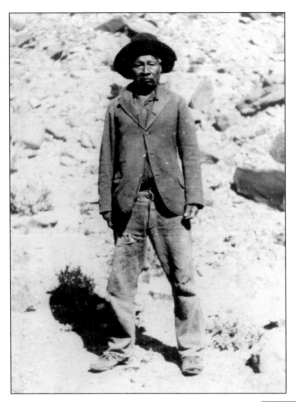

Mancos Jim's world changed drastically at the turn of the 20th century as more and more Native Americans were rounded up and placed on reservations. Jim resisted, and those who were with him were branded "renegades" for not conforming to the government's policies. The renegade bands lived a tough existence, evading the government and trying to survive off the land as their ancestors had. When asked why he and his people did not return to the reservation, Jim responded, "My papa sleeps here; my mama sleeps here: Old Mancos stay here." This photograph of Mancos was taken around 1910.

Moab was not always as clean as it is today—a riverside dump on the north side of the Colorado River near the Moab Bridge welcomed many to town. Toots McDougald took a day to explore the dump and poses with some of the treasures she found in the 1930s. Abandoned cars, barrels, and other debris were often pushed into the river from this point. The dump was later cleaned up. Moab's refuse was relegated to a new dump that at one time was known as the "Most Scenic Dump in America."

Central School in Moab housed numerous grades and provided an education for generations of Moab's students until its closure in the 1990s. Students bustle between classes in this photograph taken in 1951 shortly before Moab's uranium boom. While Moab grew during the uranium boom, the influx of students broke the school district's bank, leaving the district impoverished. The miners worked in San Juan County, where the taxes on the uranium extraction paid for schools, roads, and other amenities, but they chose to live in the larger city of Moab that did not receive the uranium tax. School enrollment went from 300 to 2,000 students in one year. It was only through the extraordinary efforts of Helen M. Knight and the school board that money was raised to build new schools and pay for teachers.

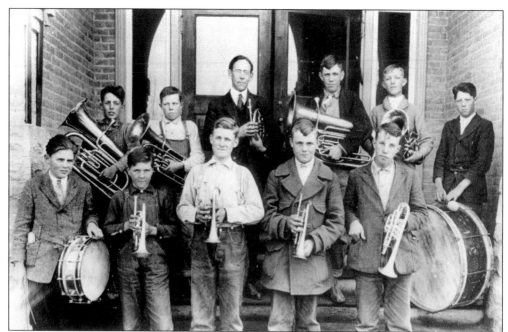

Music filled the air of early Moab, and the schools were no exception. Here, on the steps of the Central School, the 1919 band shows off its drums and brass. In the dry desert environment, brass instruments were a popular choice since they weathered the low humidity well. Mr. Summerville led the band and also played the French horn.

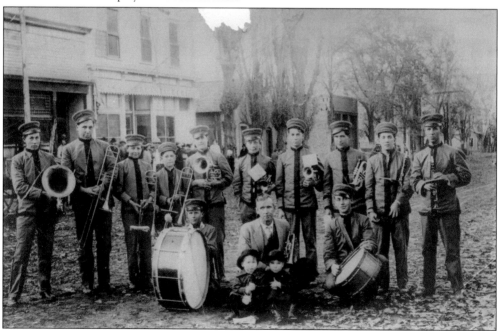

Moab loved parades, and a large part of parades was the brass band. Here, on Main Street around 1903, the young men of Moab's first school band pose in their hand-sewn uniforms with the band director and his children in front. Though the band would play military and parade marches, it also learned numerous waltzes and polkas to entertain at dances.

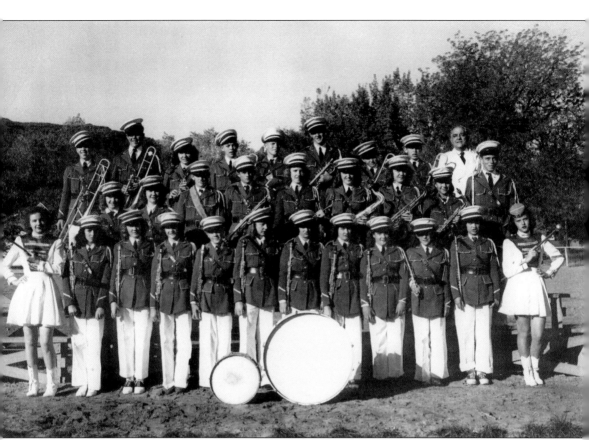

The Grand County High School marching band members stand in their new uniforms for this photograph in 1948. Though the school colors were red and white, the band uniforms were blue with red trim. The blue uniforms had been on sale, and to save money, red trim was added. The uniform colors did not matter, and the band cheered on the Grand County Red Devils to victory again and again.

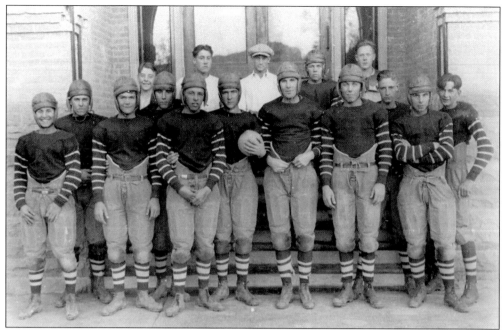

Football has always been a popular pastime in Grand County. Though the players here are wearing some padding, less was often worn. At one time, Grand County banned football from the school, citing it as being too dangerous. The young men pictured here had just won the Utah state championship around 1920.

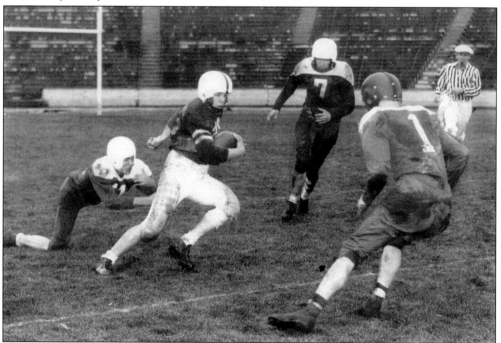

Grand County has always been proud of its football tradition. Teams continued to play and win championships over the decades. Here, a young man from Grand County escapes a tackle from the opposing team during a game in 1951.

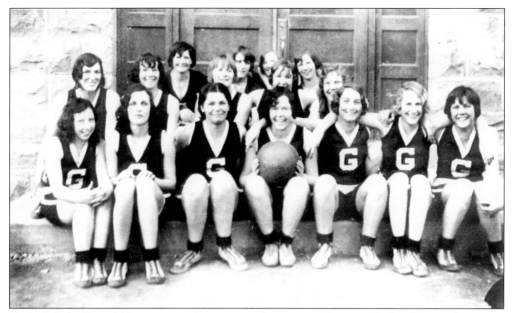

Basketball in Grand County was always a popular sport with young ladies. These players are showing off their new uniforms in 1931. Prior to this, they had worn white blouses and black satin pants. The team traveled across the state to play other schools, but their bus lacked heating, so rocks were placed under the seats after they had been heated in a fire to keep the players warm. Helen M. Knight was the coach at the time.

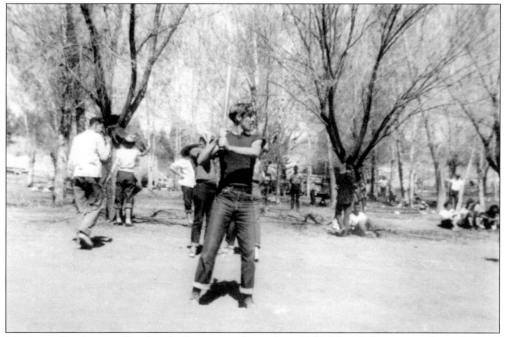

Moab youths play a pickup baseball game in the park in 1951. Moab's first city park was located several miles south of town around a spring that was used by travelers through the area. The park hosted numerous picnics and events throughout the year. Two parks were eventually opened in Moab proper, Swanny Park and Rotary Park, giving residents better access to open spaces.

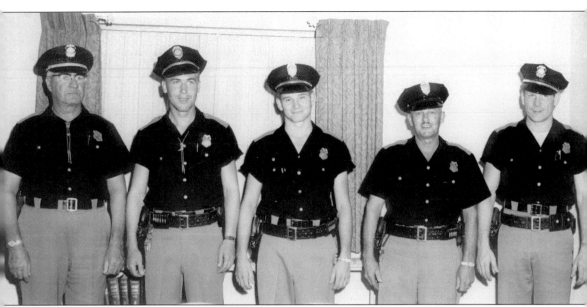

Moab city police officers found themselves very busy in the 1950s as the population grew. Originally, Moab depended on the Grand County sheriff for law enforcement, but as Moab increased in size, a larger police force was needed. Moab began to expand the police force to meet the needs of the city. From left to right are Chief Fred Adamson with officers Borreson, Boulter, Scovil, and Denny lined up for a *Times-Independent* photograph in 1956.

Thomas Murphy is standing outside his family home on Murphy Lane. The house was built by Felix G. Murphy, who had settled in Moab in 1881 after he decided that Arizona was too far south and that Moab looked fine enough. The Murphy family ran cattle, prospected for gold and uranium, and grew corn and melons. Some of the Murphy sons were talented musicians and often played at local dances.

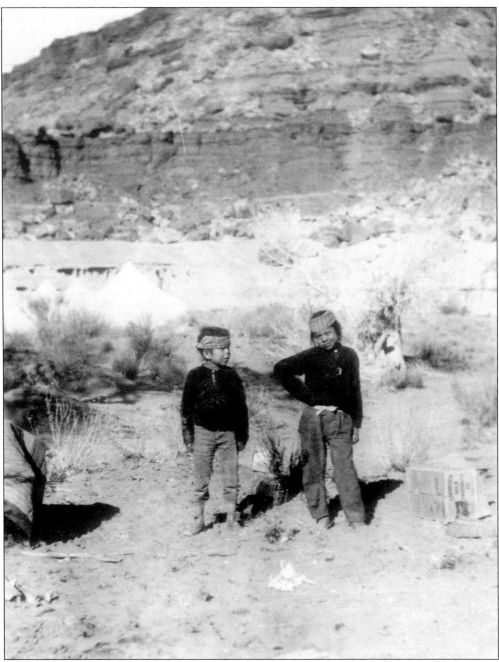

Two Navajo children play outside the town of Crystal Carbon. Many Navajo families traveled off the reservation in an effort to find work. Leaving the reservation was typically prohibited, but as the need to find employment increased, members of the various native tribes began to find ways to take work off the reservation. The Navajo had been forcibly removed from the Four Corners area in 1864 in what was called "the Long Walk." The government moved the Navajo people to Texas, where they were held at a reservation near Fort Sumner. Eventually, the cost of keeping the Navajo in Texas led to their return to the Four Corners; by 1868, their reservation was established.

Harry Goulding is best remembered as the man who introduced John Ford to the Four Corners area. Harry ran a trading post near the Arizona and Utah border. Trading with the Navajo tribes, he also gave tours and sold curios. Harry often came to Moab, where he drove the first car through Arches National Monument. Taking a cue from car races across the Sahara desert, Harry purchased large balloon-style tires that made traversing the sandy desert possible.

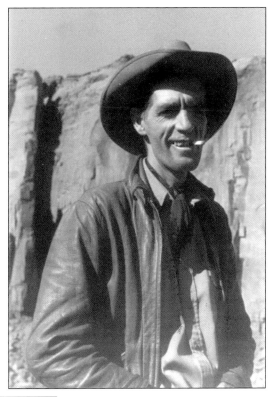

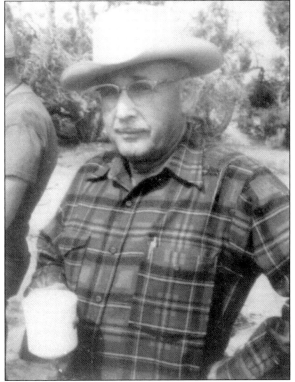

When Dan O'Laurie first came to Moab it was as an investor in Charlie Steen's uranium processing company. Dan had grown up in the Midwest but as a teenager moved to Texas to work in the oil fields. He worked carrying pipes for oil wells and construction. Eventually, he worked his way up and became vice president of the company that made the pipes in Texas. Dan liked Moab, and after Steen bought Dan's shares from the processing mill, he kept a home in town. Dan was an early supporter of the Museum of Moab and paid the first receptionist out of his own pocket. When he passed away in 1988, he left enough money to the museum to build a new building, which was named after him.

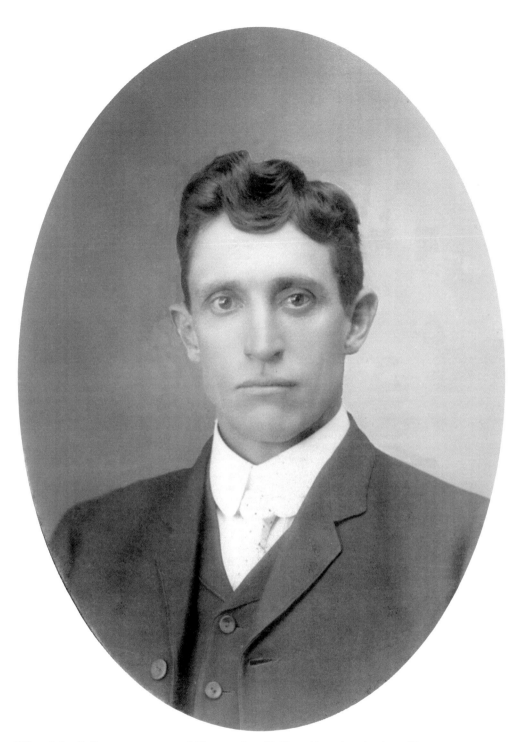

When John E. Pace was six years old he saved up $2.50 and bought a heifer calf. Six months later, he bought a second calf, thus beginning his cattle herd. When Pace arrived in Grand County in 1888 and brought his cattle, horses, and farm equipment by rail to Thompson Springs, he drove to Castleton and established his ranch.

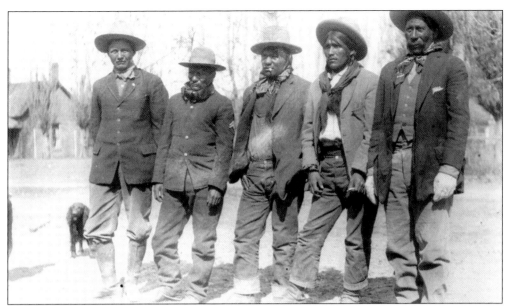

The press heralded the conflict between the family of Paiute chief Posey and the residents of San Juan County as a real "Indian War." In 1923, Posey's band of Ute and Paiute had resisted being moved from their traditional homes in San Juan County to another reservation. Several times, members of Posey's troop were accused of theft and robbery. In this photograph, Posey and his sons head toward Thompson Springs, where they would catch a train to stand trial. Eventually, Posey was killed in a skirmish in 1923, and the members of his band settled on a reservation outside of Blanding, Utah.

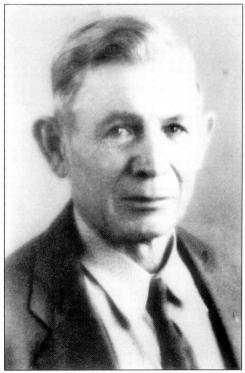

Many men came to Utah looking to get rich. For Alexander Ringhoffer, the fortune he was looking for was never found. Alexander immigrated to the United States from Hungary as a young man. Around 1920, he arrived in Grand County to engage in mining around what is known as Salt Valley. Ringhoffer was impressed by the natural beauty he saw in the nearby Devils Garden and Klondike Bluffs areas and began to write to railroad companies and the US National Park Service about the potential to preserve these areas as part of a national park or monument. Combined with the windows section, Devils Garden and the Fiery Furnace became part of Arches National Monument in 1929. Ringerhoffer passed away in Thompson Springs in 1941 and was buried in Moab.

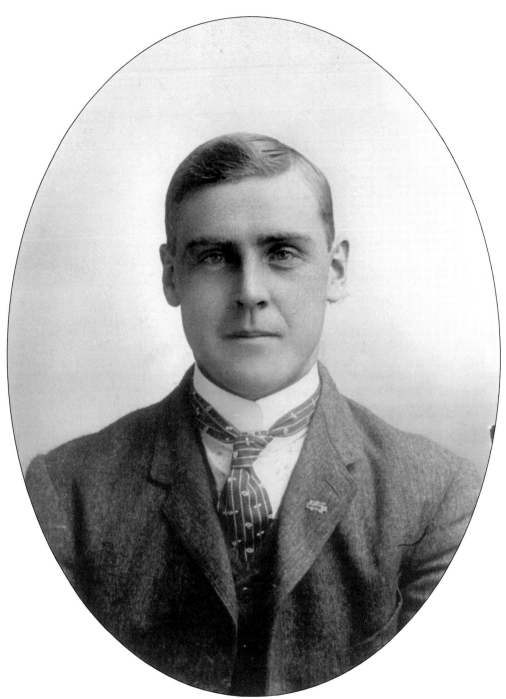

Moab sheriff John Skewes chased many outlaws in his time. His family had moved to southeastern Utah from California in the 1890s. Eventually settling in Moab, the Skewes family worked as ranchers and had an orchard. John served as Grand County sheriff for 22 years and retired from work in 1931. Though he was shot at many times, John passed away in 1952 at the age of 70.

As children, John Skewes liked Lydia Taylor quite a bit. In school, children used pocketknives to sharpen their pencils, and John would only share his with Lydia. Born in 1885, Lydia was well known for being quick on her feet and often won girls' foot races. She won the 50-yard dash nearly every time. In 1907, John was married to Lydia.

When Charles Steen came to Moab, many residents wrote him off as another prospector with a wild dream. Drilling near Big Indian in San Juan County, Steen struck riches in the MiVida Mine. Overnight, he went from rags to riches as he began to develop his mine, a drilling company, and a uranium reduction mill. His story inspired thousands across the country to travel to the Colorado Plateau and try to make it rich. Steen donated generously to building up Moab and even served as a representative to the state legislature.

For a short time while he was prospecting for uranium ore, Charlie Steen and his family lived in a tarpaper shack in Cisco, Utah. After striking it rich, Steen built a large, modern mansion above Moab. Born in Texas in 1919, Steen met and married his wife, Minnie Lee (called "M.L."), after returning from working for an oil company in Peru. In this photograph, Charlie, M.L., and their four sons pose with their red Jeep. From 1952 to 1962, the Steens made Moab their home. In that time, Charlie's discovery transformed Moab.

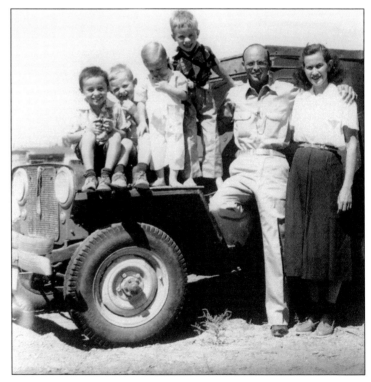

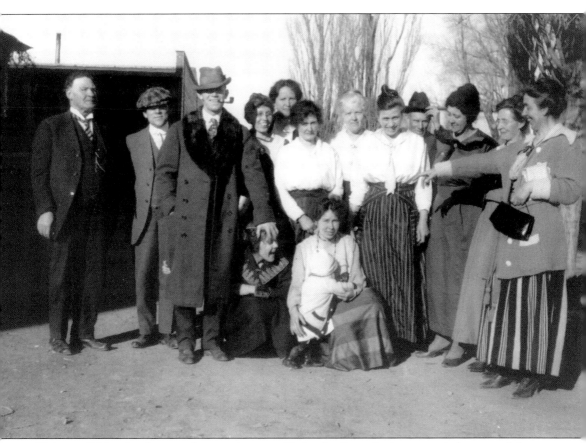

This candid family photograph was taken at a Taylor family gathering around the turn of the 20th century. The Taylors had arrived in Moab in 1881 and began ranching and farming near the north end of the valley. Norman Taylor brought his two wives, Lydia and Laurana, and their 16 children to settle in the valley. By the 1900s, the Taylors were related to nearly all the families settled in Moab through marriage.

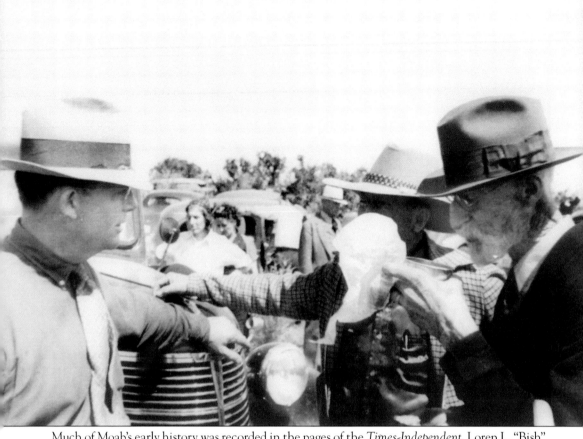

Much of Moab's early history was recorded in the pages of the *Times-Independent*. Loren L. "Bish" Taylor, pictured on the left speaking to Dr. Williams in 1929, was the longtime editor of the paper and had started his term in 1911 at the age of 18. Bish continued editing the paper into the 1950s and eventually passed the mantel to his son Sam, who edited and wrote for the papers into the early 2000s.

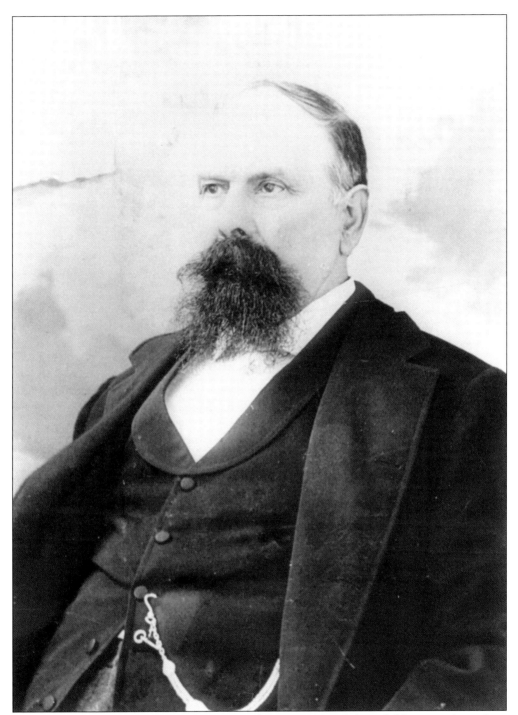

Norman Taylor came to Moab seeking to move his two wives and their children to a place where they could thrive away from anti-polygamist sentiments that had descended on northern Utah. Born in Grafton, Ohio, in 1823, Norman helped settle San Bernardino, California, under the direction of Brigham Young. He later moved to San Pete County and eventually settled in Moab, where he built the first ferry crossing of the Colorado River in Grand County.

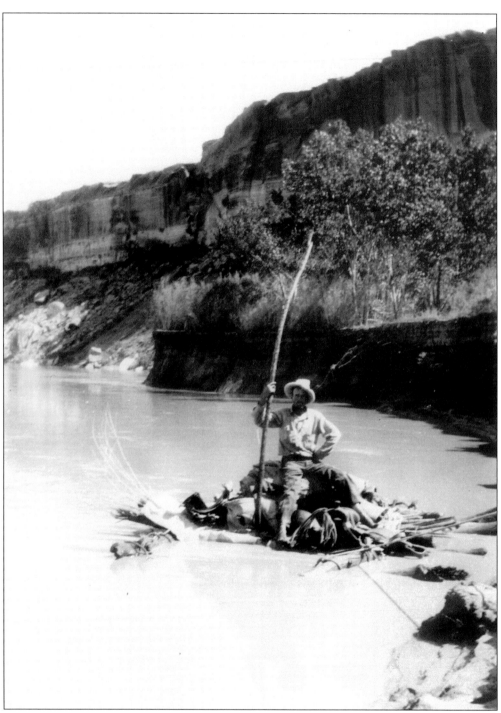

Bill Tibbets rides a raft to cross the Green River near where he ran his cattle in the early 1940s. Born to a hard life, Bill's father had been killed by a drunk in 1902 when Bill was four years old. Headstrong, Bill ran cattle for most of his life, but accusations of cattle rustling landed him in jail. Bill managed to escape and lived in hiding for many years at Robber Roost, the hideout used by Butch Cassidy.

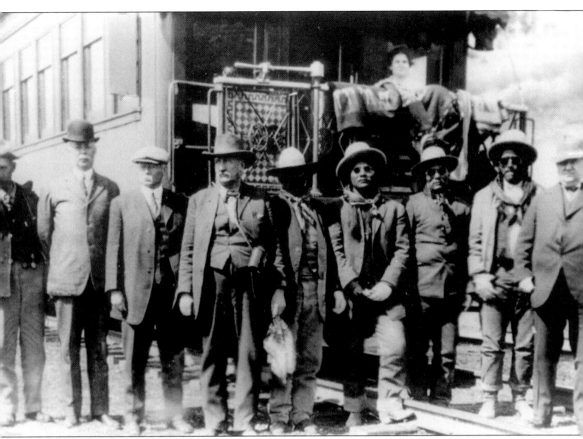

Chief Posey and his sons and grandsons prepare to board a train in Thompson Springs in Grand County after conflicts near Bluff, Utah. Tse-ne-gat, Posey's grandson, had been accused of killing a shepherd, and when Navajo policemen came to capture Tse-ne-gat, his father fired at them to drive them away. This led to a short battle that resulted in the capture and trial of Posey and his family. After the trial, the family returned to southeastern Utah, but conflicts with white settlers in the area continued to mount until Posey's death in 1923.

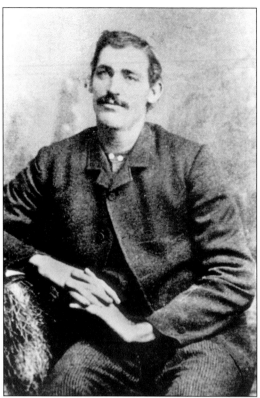

Moab's first elected sheriff served for only four years before resigning because the county was too poor to pay his salary. Dick Westwood had moved to Moab in 1890 and worked as a farmer and logger. He built a ferry at Dewey and ran it until the construction of the Dewey Bridge in 1914. He served as sheriff and as deputy on and off. In 1929, while serving as a deputy under sheriff John Skewes, he was killed by two bandits who had concealed guns on themselves before they were jailed.

Moviemaking in Moab can be credited in part to the efforts of George White. Working with Hollywood studios, George was able to convince many filmmakers to choose Grand County as a location. White had a ranch located up the Colorado River near the mouth of Castle Valley. George's ranch served as the site for several films, including *Rio Grande*.

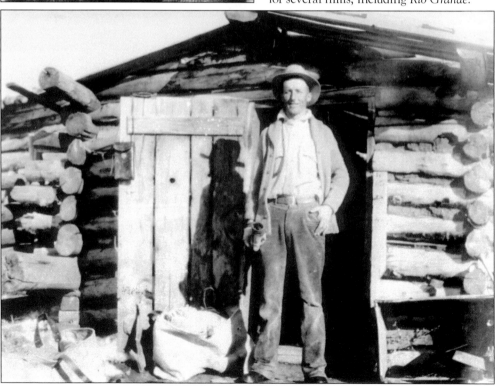

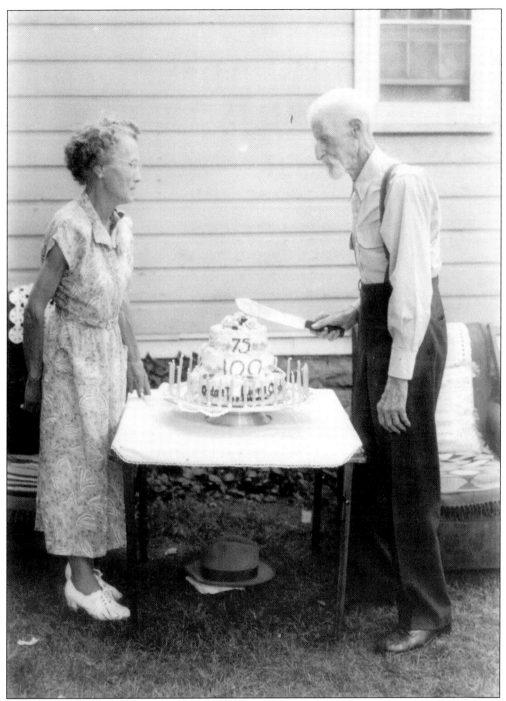

Dr. John Williams and his wife, Lavina, celebrate their mutual birthday. Twenty-five years Lavina's senior, this photograph shows Dr. Williams cutting a birthday cake on his 100th birthday and LaVina's 75th. Pres. Dwight D. Eisenhower sent a telegram congratulating the couple on their birthday. Williams passed away three years later.

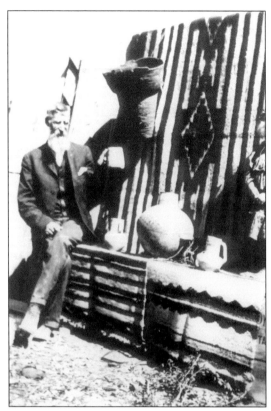

Dr. John Williams was an avid collector of Native American artifacts. Rugs, pottery, arrowheads, stone knives, and other items all comprised his collection. While he sold some of the items, he preserved the majority. In 1929, when Arches became a national monument, he gave his collection to the park for display. Lacking proper museum facilities, the rangers sent the collection away for storage. In 1958, when the Museum of Moab opened its doors, the first curator, Lloyd Pierson, requested the collection be returned to Moab. The Williams collection formed the base of the museum's collection of artifacts.

Lt. John Jacobs Williams, the son of Dr. Williams, was a flying ace and member of the Three Musketeers stunt flyers for the US Army. Having attended West Point, John became a pilot in the early days of aviation. Unfortunately, he died during a stunt in Texas. Charles Lindbergh flew the memorial flight commemorating John's death.

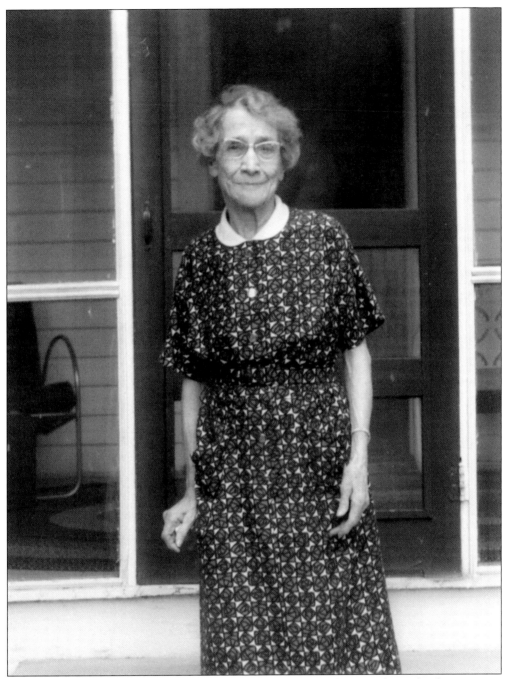

Elberta Clark was a member of Moab's first graduating class. After attending school to receive a teaching certificate, she taught school in Elgin, Utah, across the Green River from Green River, Utah. Elberta and her husband, Robert, opened the Ides Theater in Moab and ran a butcher shop and icehouse. Robert also served as a sheriff in Moab, and Elberta was assigned to feed the prisoners. One prisoner convinced their young son Jack to help him escape.

Clarence Adrian Robertson arrived in Moab on foot, having walked the 40 miles from Thompson Springs in 1898. An ambitious young man, C.A. worked as a mailman and ferry boat operator before being elected as Grand County's district attorney, despite having very little legal experience. Determined to become the best lawyer he could, he worked to attain a law degree and provided many years of solid legal defense for Grand County.

Fletcher B. Hammond began his career in Moab mining copper in Salt Valley near the present-day location of Arches National Park. Fletcher had moved his family to Moab from Bluff, Utah, around 1890. Not only did he mine for copper, Hammond owned his own mercantile business, which he ran with his sons, pictured here, and their wives. Fletcher had 12 children, six of them boys. A member of the LDS church, Fletcher paid for each of his six sons to serve missions and even served a two-year mission to England himself.

John Martin was one of the early inhabitants of Castle Valley. His wife, Cora Neely, was the last postmaster of Richardson. John and his brother Mathias were among the first prospectors to look for gold in Miners Basin. Though their efforts there proved somewhat rewarding, they ultimately chose to make their way as ranchers instead of scraping out a living on the mountain slopes.

Mathias Martin preferred to go by the name Matt. The Martin family members were key to the settlement of Cisco, Utah, where Matt's brother John worked at first as a surveyor for the Denver & Rio Grande Railroad before he and Matt headed to Castle Valley to make a life for themselves. Working together, Matt and John staked claims in Miners Basin in 1880, but eventually built ranches and were married in Castle Valley.

Addie Maxwell was the proprietress of the Maxwell House Hotel and the adjacent millinery shop. Addie had come to Moab with her father, Norman Taylor, and for a short time had lived in the ruins of the Elk Mountain mission while her family was building a house in Moab. Known as "Aunt Add," Addie was one of Moab's first businesswomen and worked hard to make a living for herself and her family.

Converts to the LDS church from Sweden, the Peterson family arrived in Utah in 1870. John Peterson was only two years old when his family crossed the Atlantic. As an adult, he worked as a cowboy and bronco buster and on a visit to Monticello, Utah, he happened to stop in Moab where he noticed a beautiful young lady by the name of Delilah Jane Warner. John and Delilah married and had nine children. John, active in the LDS faith, served many positions, including missionary to the southern United States and a bishop in Moab. Here, the Peterson daughters pose for a picture with their newly born sister.

The Rays were among the first white families to pass through the Moab Valley. Despite rumors of fearsome native tribes in the area, the Rays chose to settle in Paradox, Colorado, on the southeast side of the La Sal Mountains. Unlike many settlers, the Rays were never attacked by local tribes. It was believed that it was Mrs. Ray's kindness to the Native Americans in the area that protected the family from the belligerence between the white settlers and the various Indian bands that roamed the Colorado Plateau. They eventually moved across the border to La Sal, Utah, where they were famous for their love of horse racing.

Around 1890, the Pittsburg Cattle Company, which had run cattle in the Montrose, Colorado, area, decided to close its operations. Fred Prewer, J.M. Cunningham, and T.B. Carpenter bought up the stock from the company and began their own cattle operation. Prewer later sold his holdings in the company and married Helen Grimes in Denver, Colorado. The couple poses for a photograph commemorating the occasion in 1898. In 1894, Helen had witnessed what she called "an invasion" of the Ute tribe as US Indian Agents tried to force the tribe out of Colorado and into Utah. She recalled that the governor of Colorado sent in troops that removed the Utes to reservations in Utah.

Lloyd Pierson came to Moab as an archeologist for Arches National Park. After serving in World War II, Pierson found an interest in the ancient cultures of the world, and when he returned from the war, he began studying archeology at the University of New Mexico. Here, he poses with childhood friend Eddie Thompson at a Boy Scout camp. He met his wife, Marian, in Albuquerque, where they were married in 1947. By the 1950s, he had arrived in Moab to begin work excavating numerous archeological sites and eventually began working with community members to start the Museum of Moab so local artifacts could be preserved.

Randolph Stewart arrived in Utah with the second company of Latter-day Saints to enter the Salt Lake Valley in 1847. Though only 13 at the time, he had driven his family's team of oxen across the entirety of the Great Plains on their journey to their new home. In 1881, Stewart was called to be bishop of the LDS in Moab, and so he moved his three wives and children to Moab. A polygamist, Stewart was jailed several times but eventually freed. He had 23 children and, at one time, owned much of what would become the town of Moab.

When Orlando Warner's family settled in Moab between Mill and Pack Creeks, they brought with them cherry seeds and yellow currants to plant on their farm. Here, Warner and his family enjoy a photo session. Orlando served as a member of Moab's first LDS bishopric in the role as second councilor under Bishop Randolph Stewart. Not only a leader in the church, Warner served as a county councilman for some time, and worked building several stretches of the Denver & Rio Grande Railroad through Grand County.

DISCOVER THOUSANDS OF LOCAL HISTORY BOOKS FEATURING MILLIONS OF VINTAGE IMAGES

Arcadia Publishing, the leading local history publisher in the United States, is committed to making history accessible and meaningful through publishing books that celebrate and preserve the heritage of America's people and places.

Find more books like this at
www.arcadiapublishing.com

Search for your hometown history, your old stomping grounds, and even your favorite sports team.